IMAGES
of America

HEMET

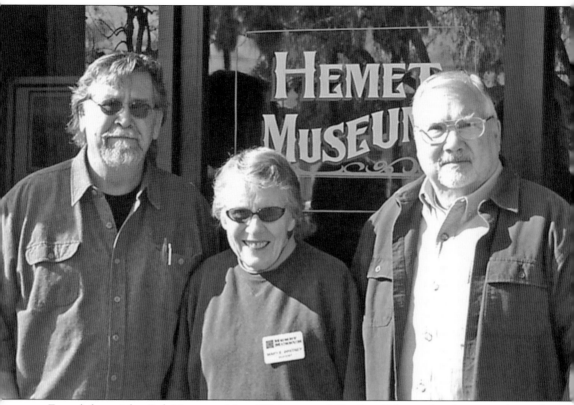

From left to right, Bob Norman, Mary Whitney, and Gordon Sisk are the three members of Hemet Area Museum Association (HAMA) who volunteered to compile *Hemet*, another in the Arcadia Publishing book series Images of America.

*To: Larry ~ Joan
I hope you enjoy
this as much as
I did writing the
Text. Best Wishes
Mary E Whitney*

ON THE COVER: In 1913, Abram Smith built the first motion picture theater in Hemet on south Florida Avenue between Harvard and Carmalita Streets. He lived with his mother and did side jobs building fireplaces. In 1906, he married Henrietta Wethered, sister to Anne Wedemeyer, wife of the local druggist, F. G. Wedemeyer. Abram is standing by the surrey with the fringe on top, in which Henrietta (in white dress) is sitting in front of Abram's mother. (Courtesy Swift Collection.)

IMAGES
of America

HEMET

Hemet Area Museum Association

ARCADIA
PUBLISHING

Published by Arcadia Publishing
Charleston SC, Chicago IL, Portsmouth NH, San Francisco CA

Printed in the United States of America

Library of Congress Catalog Card Number: 2008920089

For all general information contact Arcadia Publishing at:
Telephone 843-853-2070
Fax 843-853-0044
E-mail sales@arcadiapublishing.com
For customer service and orders:
Toll-Free 1-888-313-2665

Visit us on the Internet at www.arcadiapublishing.com

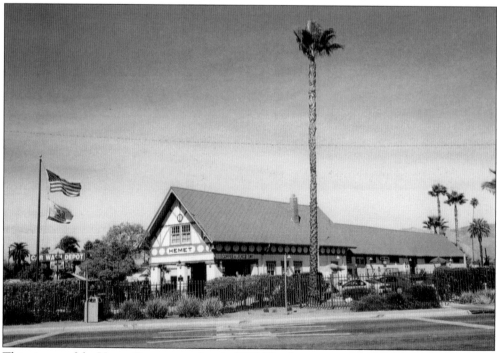

This picture of the Hemet Depot was taken in 2007. The front portion is the old passenger section, constructed in 1914 and now occupied by a café. The freight section is behind, constructed in 1898 and now occupied by the Hemet Museum. In 1987, a citizens group called SAVE OUR STATION (SOS) purchased the depot from the Santa Fe Railroad to preserve part of Hemet's past.

CONTENTS

ACKNOWLEDGMENTS

Three members of the Hemet Area Museum Association (HAMA) prepared this book for the benefit of the entire membership. Three other members of HAMA—Tom Garnella, Anne B. Jennings, and Virginia Searl Sisk—are gratefully acknowledged for writing the book proposal, writing the chapter outline, and serving as a "go-for," respectively.

People outside HAMA helped in their own unique way, and we thank them. Pam Hubbell, a volunteer at the Hemet Public Library Heritage Room, assisted in retrieving photographs from the Swift Collection, owned jointly by HAMA and the Hemet Public Library. Mark Goldberg assisted with the book proposal. Hemet High School teacher John Hill provided the picture of the third Hemet High School for chapter four. Eleanor McIntyre and the Sierra Dawn Homeowners Association, Inc., contributed photographs and historical information about Sierra Dawn. Finally, Gustavo Bermeo of Valley-Wide Recreation and Park District provided two of the photographs for chapter eight—"Hemet Today."

Although all three are no longer with us, HAMA recognizes and thanks Laura and Clarence Swift and the *Hemet News* 1893–1999 for the preservation of and contributions to Hemet's history.

The help, guidance, and support given by Debbie Seracini, acquisitions editor for Arcadia Publishing, were invaluable throughout this project.

Unless otherwise noted, the photographs in this publication are courtesy of the Hemet Museum.

INTRODUCTION

Even before its inception, Hemet was a planned community, developed on 6,000 acres in the San Jacinto Valley. Two men, Francisco Estudillo and Henry T. Hewitt, originally owned the 6,000 acres; both lived and were businessmen in the San Jacinto Valley in the 1870s.

Francisco Estudillo inherited his land from his father, Jose Antonio Estudillo. Mexican governor pro tem Manuel Jimento gave Jose 35,503 acres in 1842 for his work as justice of the Supreme Tribunal of Mission San Luis Rey, located northeast of what is now Oceanside. The 35,000-plus acreage was called Rancho San Jacinto Viejo. Using a caretaker and American Indian vaqueros, Jose Estudillo raised stock and horses on his rancho while living in his San Diego mansion. When he died in 1852, his youngest two sons, Jose Antonio Jr. and Francisco, inherited the Rancho San Jacinto Viejo lands. In 1871, Francisco sold 8,000 acres to Henry T. Hewitt for $2.50 per acre. Hewitt, who came from Santa Rosa, California, also purchased a general store from the Russian Procco Akimo and constructed a hotel in what became the town of San Jacinto. The rest of his acreage was put to raising cattle and grains.

In 1877, for health reasons, building contractor and engineer Edward L. Mayberry moved his family from San Francisco to Southern California. He purchased ranch land in Alhambra, where he could indulge in one of his favorite activities, raising and racing Standardbred trotters. While attending race meets, he became acquainted with Charles Thomas and Hancock M. Johnston. Thomas came to the San Jacinto Mountains in 1861 to raise cattle and horses, especially trotters, on 4,000 acres he purchased from American Indians and the U.S. government. Johnston also owned land in the San Jacinto Mountains close to the Thomas ranch where he raised polled Durham cattle and trotters. Thomas and Johnston purchased two sections of land from the Southern Pacific Railroad in what was then called Hemet Valley, a 4,300-foot-high mountain valley.

Mayberry visited the Thomas and Johnston mountain ranches in 1884 and traveled through Hemet Valley, noting how the valley sloped gently to the northwest and a stream ran through it and a 40-foot-wide gorge between two high bluffs at the end of the valley. The stream, called South Fork, was one of three source branches of the San Jacinto River. Johnston and Thomas probably told Mayberry about the two sections of Hemet Valley land they owned.

Because of his 1884 San Jacinto Mountain visit, Mayberry saw a wonderful opportunity to make a lot of money. He envisioned building a dam across the 40-foot-wide gorge in Hemet Valley. In addition, he would buy land in the San Jacinto Valley and sell it to farmers. Water runoff from rains and snows in the mountains could be held back and saved in a lake that would form behind the dam. During dry summer months, water would be released from the lake, flow down the San Jacinto riverbed, and be conveyed to lands purchased by farmers, who could grow every conceivable crop indigenous to Southern California.

Mayberry was wealthy but not that wealthy. He knew he would need more money for his plan to be successful. He thought Johnston might help, but Johnston was also not that wealthy, although he was willing to enter into partnership for any development Mayberry planned. Mayberry turned to his friend William F. Whittier, a wealthy San Francisco paint merchant. Whittier traveled to

the San Jacinto Valley and Mountains and later explained the outcome of that trip: "Our principal business at that time was shooting quail, but we looked the country [San Jacinto Valley] over and he [Mayberry] had this project in view and he laid it out to me, and during that trip we went up to the Hemet Valley where the dam was subsequently built; and I should say within a year after that we entered into negotiations for that property [Hemet Valley] there."

In 1886, Mayberry, with Whittier's power of attorney, purchased 3,000 acres from Francisco Estudillo and 3,000 acres from Henry T. Hewitt in the San Jacinto Valley. The two 3,000-acre parcels were adjacent, flat, and sloping gently to the northwest, perfect for irrigating. Mayberry and Whittier paid Estudillo and Hewitt each $15 per acre. In February 1887, they formed the Hemet Land Company and the Lake Hemet Water Company with Hancock M. Johnston and his section of Hemet Valley land. They also purchased Charles Thomas's Hemet Valley section. Whittier and Mayberry together owned 90 percent of the stock in each company.

Beginning in 1887, Mayberry built a road up the mountains to Hemet Valley, started the town of South San Jacinto north of Park Hill on the land purchased from H. T. Hewitt, and built the Lake Hemet Dam, which held back mountain waters then named Lake Hemet. While he was doing all of this, the California Southern Railroad Company decided to run its tracks from Perris, California, to land donated by Francisco Estudillo for a San Jacinto depot. When the railroad did this, Whittier and Mayberry realized that without a railroad, their South San Jacinto town was doomed. Therefore, they changed their town site to where the railroad tracks went through part of the 3,000 Estudillo acreage. They named their new town Hemet. By the end of 1894, Hemet had a train depot, hotel, grammar school, high school, Baptist church, newspaper, and most important of all water to grow almost anything.

In 1910, approximately 900 Hemet residents voted for incorporation. In 2010, the projection is that the Hemet trade area will have more than 150,000 residents who will participate in Hemet's Centennial Celebrations. These 100 years have been historically and culturally eventful for our city and its environs. Agriculture has waned, but retirement and bedroom communities have flourished. Our schools are among the best, we abound in community playgrounds and activities, our hospitals serve those living in and outside the San Jacinto Valley, and commercial and retail centers are thriving. Through all of this, the Lake Hemet Dam stood in Hemet Valley in the San Jacinto Mountains, holding back precious waters.

One

BUILD IT AND THEY WILL COME

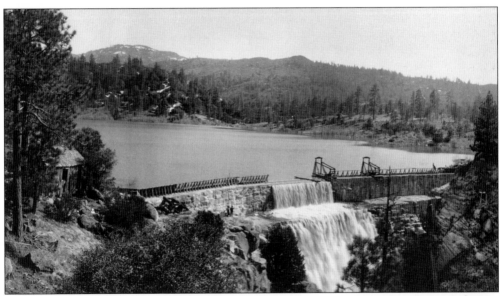

The Lake Hemet Dam was constructed of granite and concrete between 1890 and 1895 by Edward L. Mayberry and his 100-man crew. In order to convey 400-pound barrels of cement for the dam, a 23-mile road was built from the San Jacinto Valley to the dam site, located in the 4,300-foot-high Hemet Valley in the San Jacinto Mountains. When finished, the dam was 122.5 feet high and 260 feet wide with a 28-degree curvature, holding back a capacity of almost 42 billion gallons of water. Water behind the dam traveled 18 miles down the San Jacinto riverbed to a receiving reservoir. From there, the water was distributed in flumes and later pipes to farmers who purchased their land and water from the Hemet Land Company and the Lake Hemet Water Company, both owned by Mayberry and his partner, William F. Whittier. A dam keeper occupied the cabin hidden in the pine trees on the left in the picture.

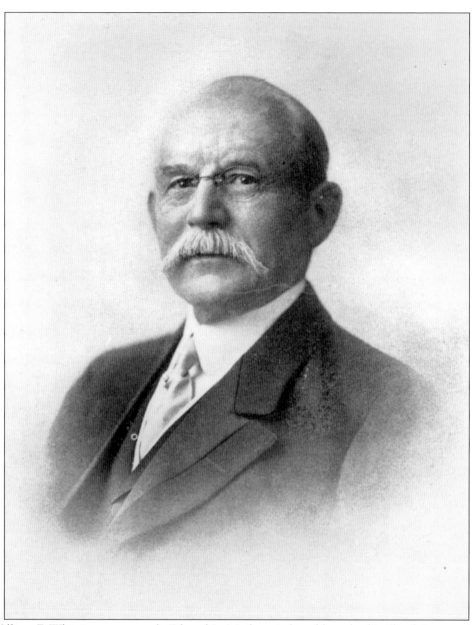

William F. Whittier was not only Edward L. Mayberry's friend but also his "bank," possessing millions of dollars. Born in Maine in 1832, Whittier came to San Francisco in 1854 and started Whittier, Fuller, and Company, predecessor to Fuller Paints. Whittier saw the possibility of making even more money by joining Mayberry in the development of water and land in the San Jacinto Mountains and Valley. Whittier's company owned clipper ships in which 400-pound barrels of cement were used as ballast from Belgium around Cape Horn to San Diego. The California Southern Railroad transported over 20,000 barrels of cement to the San Jacinto Valley. In addition to the dam, Whittier paid for Hemet company offices, the first hotel, a warehouse, and stores, all built by Mayberry. Whittier lived in a mansion in San Francisco, traveling to Hemet from 8 to 10 times a year. In addition, he wrote daily letters giving orders and requesting reports on everything that occurred in Hemet. Whittier died in 1917 at the age of 85 in his San Francisco mansion.

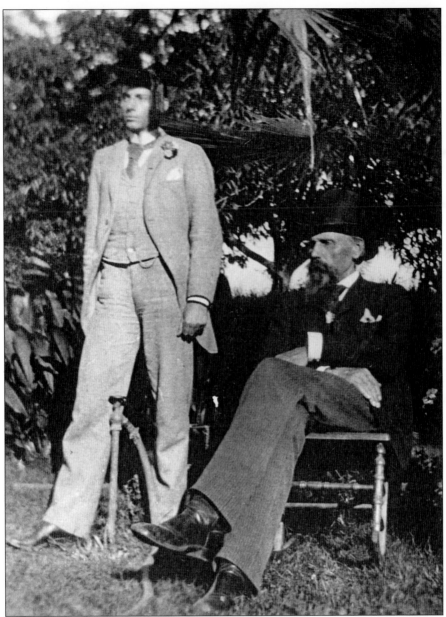

Edward L. Mayberry Sr. is sitting in the backyard of William. F. Whittier's San Francisco mansion in June 1896. He had been ill for the past few months, thus the reason for his sitting. He traveled to San Francisco for Edward L. Mayberry Jr.'s graduation from the University of California, Berkeley with a bachelor's degree in architecture. In 1929, Mayberry Jr. (standing) constructed the 60-room Hotel Alessandro in Hemet on the very spot his father built Hotel Hemet in 1894. Born in 1834 in Maine, Mayberry Sr. came to San Francisco in 1861 as a trained and experienced builder. During his San Francisco years, he built the Grand Hotel, the Napa State Insane Asylum, and many beautiful mansions, one of which was for Whittier. Mayberry Sr. and his family moved to Alhambra in 1877 where he started El Molino Ranch, concentrating on raising and racing world-class trotters. Mayberry died at 68 years old in 1902 at his El Molino Ranch. Because of a lawsuit, Whittier got all of Mayberry's real and personal property. (Courtesy Harry Humason.)

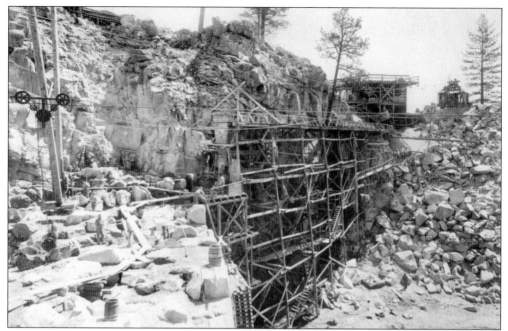

The construction of the Lake Hemet Dam is on the lower left in this picture. The two poles on top of the dam were an "A" frame to help move granite stones to the dam. The scaffolding to the right of the dam held a small-gauge tramway for iron carts to haul mixed concrete from the multistory mixing house. The dam keeper's cabin is on the upper right.

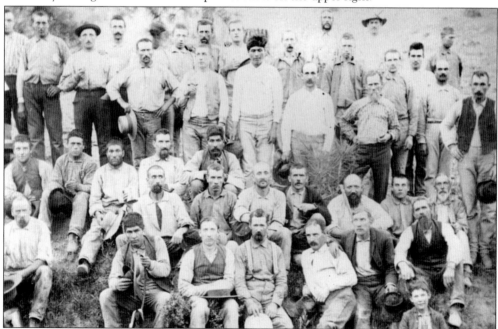

Some of the men who constructed the Lake Hemet Dam from 1890 to 1895 appear with Edward L. Mayberry, sitting on the right side of the first row behind the young boy. The boy handled signal duties. While sitting in a lookout shed perched high on a bluff, he controlled all the granite moved to the dam by telegraphic communication with the engineer in charge.

In 1906, Lake Hemet water overflowed the dam for the first time since it was constructed. When he learned about this event, William F. Whittier dashed to Hemet on the "Owl Special" train from San Francisco and to the dam on horseback the next morning. He was 74 years old. He lamented to photographer Stillman I. White about Edward L. Mayberry not seeing the event. Things were not always that cheerful for Whittier. In September 1900, the dam held back no water as a result of a severe drought. Whittier ordered the digging of 19 wells in Hemet Valley above the lake and the cleaning out of creeks and springs leading into the lake. He also made every attempt to conceal the drained lake from the farmers in the San Jacinto Valley, not allowing them to view the lake.

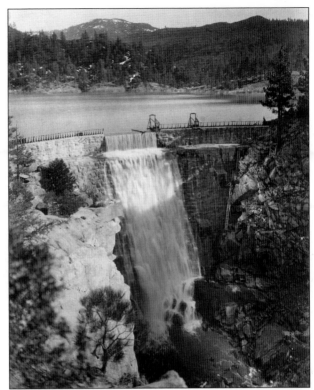

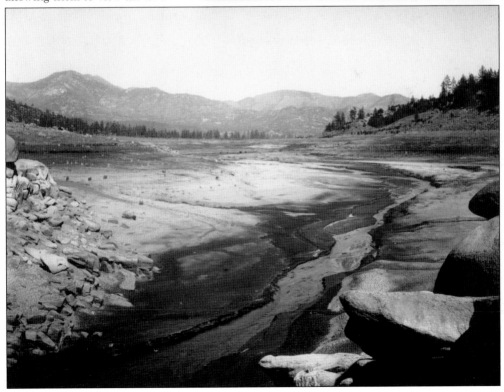

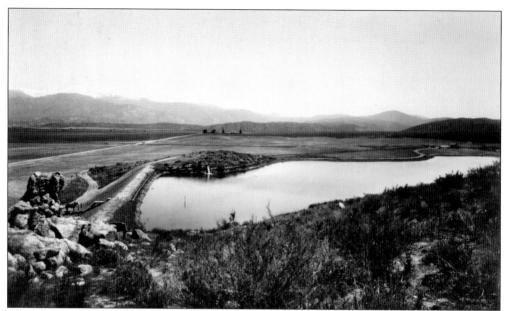

During 1887, Edward L. Mayberry supervised the construction of Little Lake, a receiving reservoir for Lake Hemet water, approximately four miles from the town of Hemet. Unlike the Lake Hemet Dam, Little Lake Dam was earthen, 14 feet high, and 300 feet long with a holding capacity of 16 million gallons. After the earthen dam broke in 1908, William F. Whittier replaced it with a concrete dam.

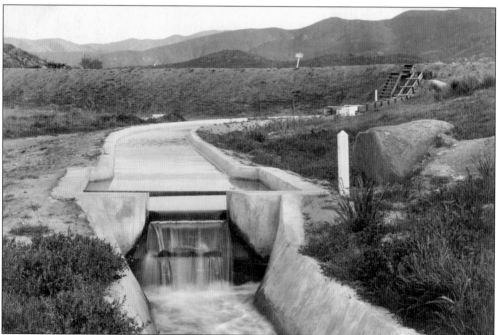

Water was conveyed from Little Lake by a large concrete flume, which included a gauging weir that measured miners' inches of water. In this photograph, the weir is behind the downward flow of water. After passing the weir, water flowed into smaller concrete and wooden flumes with smaller weirs to sold lands. Farmers paid for water based on miner inches used.

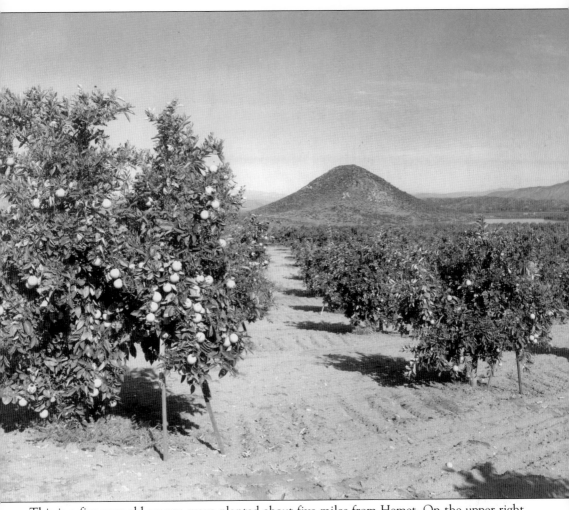

This is a five-year-old orange grove planted about five miles from Hemet. On the upper right in this picture, the narrow, white image is Little Lake. Citrus was planted in the eastern part of the San Jacinto Valley, named Valle Vista, because the San Jacinto Mountains, not shown in the picture, sheltered the orange trees from killing frosts. Naval and Valencia oranges and lemons were grown in Valle Vista until the late 1990s, when citrus growers switched primarily to Super Red grapefruit. In 2008, grapefruit is shipped east and west to Japan, China, and other Asian countries.

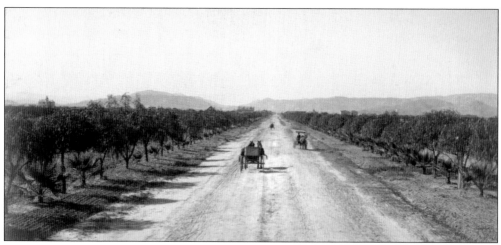

This horse and buggy is heading for Hemet on Florida Avenue. Four two-story buildings loom above the trees. The building on the left is the high school on Acacia Avenue, built in 1894. The next building is Hotel Hemet at Florida Avenue and Harvard Street. The third and fourth buildings are the Hemet Opera House on Harvard Street and the floor mill on Latham Avenue next to the railroad tracks. (Courtesy Swift Collection.)

Born in Kentucky in 1866, Philip N. Myers was the biggest frog in the little pond of Hemet during the late 19th and early 20th centuries. From 1896 to 1907, he worked as secretary and then general manager of the Hemet Land and Lake Hemet Water Companies. His years at the helm of these companies coincided with the first of everything in the new town.

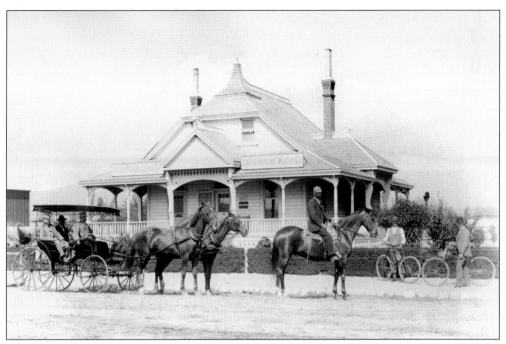

Edward L. Mayberry constructed this office/house for the Hemet Land Company and the Lake Hemet Water Company, as the two signs opposite the main entrance announce. Mayberry also used the house for a residence before he constructed Hotel Hemet. William F. Whittier is the man with the dark hat and suit seated in the buggy. The man on horseback is Philip N. Myers, general manager. (Courtesy Swift Collection.)

From San Francisco, William F. Whittier was constantly bombarding general manager Philip N. Myers, first by telegraph and later by telephone, about keeping accurate records of receipts and bills. The Hemet Land Company Cash Book for 1894 contains pages and pages of handwritten entries, one side for debits and the other side for receipts.

CASH BOOK HEMET LAND COMPANY 1894

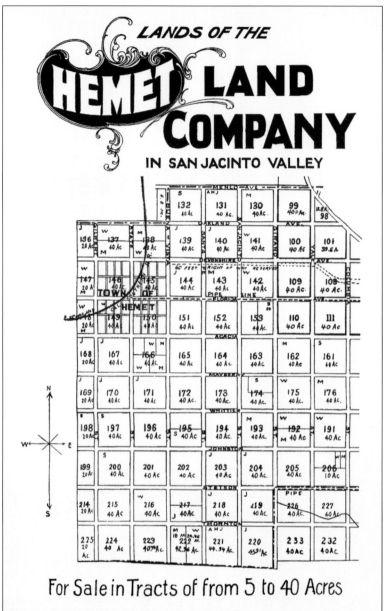

LANDS OF THE

HEMET LAND COMPANY

IN SAN JACINTO VALLEY

For Sale in Tracts of from 5 to 40 Acres

This Hemet Land Company map presents the 3,000 acres William F. Whittier and Edward L. Mayberry purchased from Francisco Estudillo in 1886. At the same time, they purchased another 3,000 acres east of the Estudillo lands from Henry T. Hewitt. They paid Estudillo and Hewitt $15 per acre. They initially sold the land in 5- to 40-acre parcels for $100 per acre at seven percent interest, charging separately for a guaranteed water supply. In 1892, they filed the official map for the entire acreage in San Diego County. Riverside County was not formed until 1893. The map also included the site for the mile-square town of Hemet, located at the curve where the California Southern Railroad tracks swung north to the city of San Jacinto. They named two of the streets on the map Whittier and Mayberry Avenues. Whittier and Mayberry planted 2,500 acres of their land to every conceivable grain, vegetable, olive, fruit trees and vines, and alfalfa in order to demonstrate what would grow on their lands.

Two

AGRICULTURE AND
THE RAILROAD

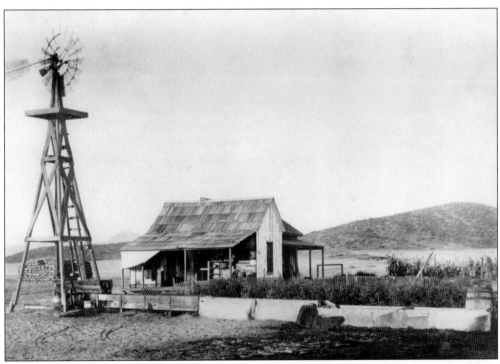

Idella and Oliver Searl moved to this house in Diamond Valley in 1893 after the birth of their first child, Edgar. Enlargements of the house occurred with the arrival of each of their next five children. There were nine children in all, six boys and three girls. Naturally money was a major concern, and the Searl brothers met the challenge in one instance by going into the hog business on a large scale. To feed the hogs, they decided to collect garbage. In 1928, the Hemet City Council gave a one-year exclusive franchise to the Searl brothers to collect city garbage. The brothers charged 75¢ a month for each residence from which garbage was removed. Payment of the 75¢ entitled each family two garbage collections each week and two trash collections each month. Garbage collections were made daily from restaurants. In the 1960s, the Searl family became one of the largest dry-land grain farming families in the area. (Courtesy Virginia Searl Sisk.)

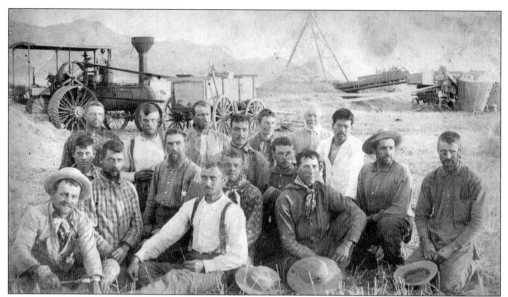

Before irrigation water arrived, early settlers living in Diamond Valley, four miles south of Hemet, were grain farmers, dependent on fall and winter rains to grow their barley and wheat. This crew of 17 men is taking a dinner break from threshing wheat. The steam engine shown powered the stationary threshing machine, which separated the grain from the straw. In this early picture, the grain was loaded into wagons.

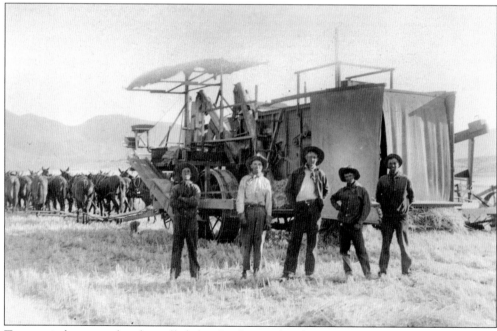

Twenty-six horses and mules pulled this Searl-owned Holt Harvester. The harvester cut a 22-foot-wide swath of barley and threshed the grain, which was loaded into burlap gunnysacks. A sack-sewer closed each sack with six stitches and a tie-off. The 100-pound sacks were left on the ground for pick up. From left to right, the five men are Clyde and Gerald Searl, Bob Crawford, Pete Hibbard, and Ed Searl. (Courtesy Virginia Searl Sisk.)

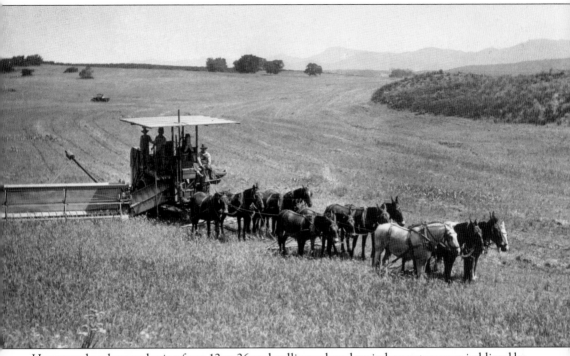

Horses and mules numbering from 12 to 26 and pulling colossal grain harvesters were jerklined by drivers who directed the lead team leader with a single leather line. This line was passed through the rings of the bridle bits of all the horses on the left side and was finally buckled into the bit of the left lead horse. A steady pull on the line and a "Gee Haw" by the driver would swing the lead team leader in a left-hand turn, and all the other teams followed in proper order. A series of light jerks signaled the leader to change his course to the right, forcing his workmate(s) to move that direction, and again the teams followed the leaders in the turn. Lead horses were jerklined trained with a gee string, a short length of leather line firmly attached to the bridle bit in order to tighten the horse's head and make him obey the driver's steady pull or light jerks. (Courtesy Swift Collection.)

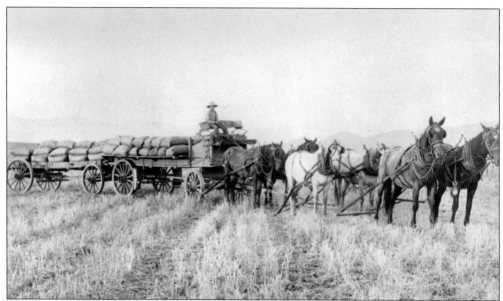

Twelve-year-old Harry Oliver Searl and his team are taking 100-pound sacks of barley from a Diamond Valley field in 1906 to the Hemet train depot. Thirty years later, Harry was elected mayor of Hemet and served an eight-year term, helping the city to weather a depression and World War II and establish its first community hospital. (Courtesy Virginia Searl Sisk.)

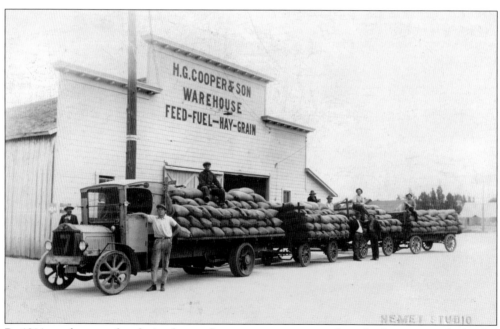

By 1914, trucks started replacing horses for carrying grain to markets. In this picture, the loaded truck, like horses, pulled a heavy load—three trailers. In 1954, Diamond Valley ranchers received irrigation water for the first time from Eastern Municipal Water District. After that, potatoes, onions, carrots, lettuce, and other garden vegetables replaced barley, oats, and wheat.

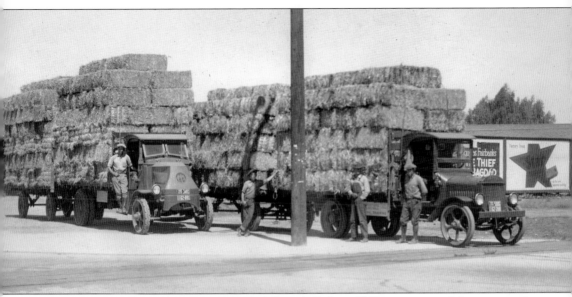

With the advent of irrigation water, alfalfa followed. Before alfalfa, cows were fed a variety of grasses, grains, and vegetables. However, potatoes and beets produced milk that was flat and watery in texture; squash was too cow fattening; and green cornstalks made the cow's milk too sweet. When fed to cows, alfalfa proved superior for both feed and milk. It was very adaptable to the Hemet climate and soil. Alfalfa is best when it is irrigated. Alfalfa crops were harvested six or seven times a year and shipped from the valley, first by train and later by truck.

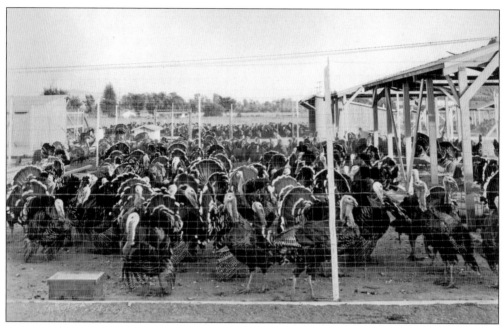

Growing and selling turkeys brought Hemet national recognition starting in the 1920s. The leader of this industry was Jay C. Loomis, who owned a Hemet warehouse where the turkey industry evolved. In 1936, Loomis started the Hemet Utility Turkey Show that eventually became the Riverside County Farmers Fair. Loomis also served as mayor of Hemet from 1932 to 1934.

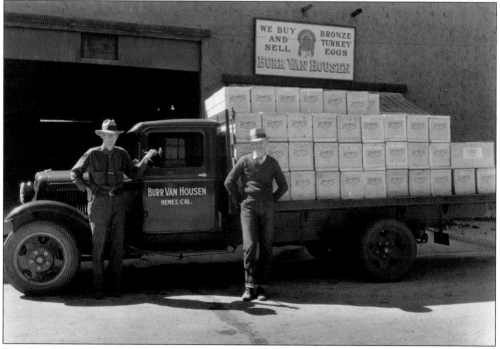

Burr Van Housen, on the left in this picture, was another mayor of Hemet (1945–1950) involved in the turkey industry. Van Housen sold turkey eggs nationally and internationally. Turkey eggs were one of the first Hemet products shipped by air from the Hemet-Ryan Airport.

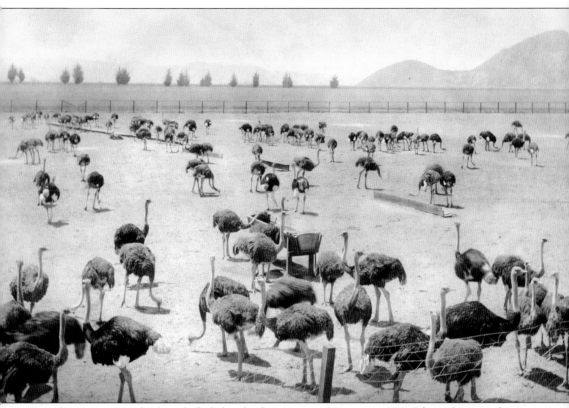

Ostriches—over 500 feathered, flightless birds—came to Hemet in 1909. Edwin Cawston from Pasadena purchased 360 acres northwest of Hemet at Seventh and Sanderson Streets and started the Cawston Ostrich Farm, supposedly the largest ostrich farm in the world. At one time, 1,500 birds roamed the property and supplied plumes for hats and dress decorations. The farm lasted five years, until 1914, when property taxes doubled and fickle fashion styles reduced the demand for ostrich plumes, forcing the sale of the birds and the farm's closure.

The Hemet Orange Growers Association was the predecessor to the Sunkist Association; both processed fruit from numerous citrus groves planted east of Hemet. The quality and appearance of the Valencia oranges were so good that Sunkist manager Robert McIntyre selected fruit from Samuel Jewell's orange ranch to compete in the Southern California Fair in 1926. Jewell's fruit won first place.

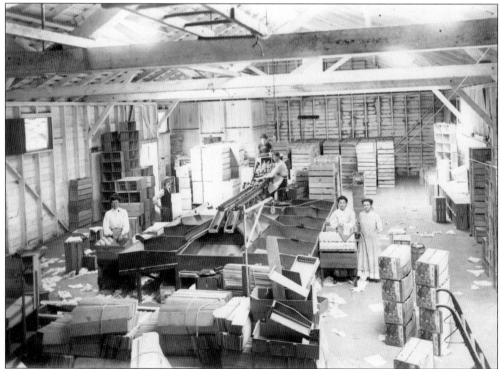

The Hemet Orange Packing House was started in 1907 and staffed by women. Summer Valencias and winter navels were brought to the house in bulk. The oranges were graded and placed on the conveyor tracks from which they rolled into individual bins. The women then packed the oranges in wooden boxes. Picked lemons were sold and shipped in bulk.

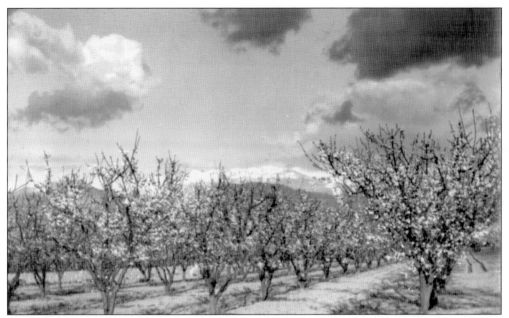

Except for the Ramona Pageant, apricots were Hemet's claim to fame. At one time Royal, Blenheim, and Tilton apricot trees covered 5,000 acres. This picture of a grove of apricot trees in bloom presents a hazardous threat—snow on Mount San Jacinto just above the trees, which meant freezing temperatures. Hopefully the temperature did not drop too low each night and the blooms turned to cots.

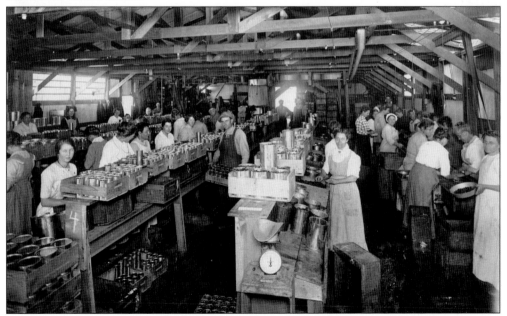

In 1910, four Hemet leaders organized the Hemet Canning Company to handle the apricot and peach crops. For two weeks in the summer, people spent their working hours as cutters, cookers, packers, and foremen. Money for school clothes or other necessities came from hard-earned wages at the cannery. As the tonnage increased, Mexicans and outside students came to Hemet to help and earn.

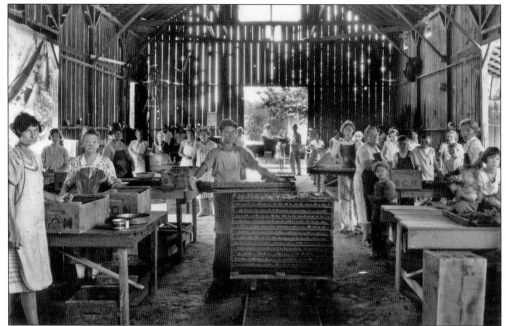

In 1924, the Hemet Canning Company became the Hemet Packing Company, where apricots were not only canned but also dried. Brought to dry sheds, the cots were cut, pitted, and placed in wooden trays, one layer only with the meaty side facing up. Stacked, the trays were moved on small-gauge tracks first to sulfur houses, to preserve color, and then to dry yards.

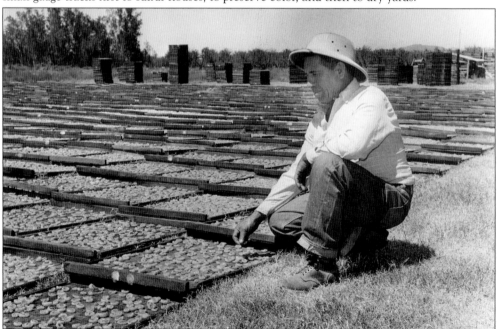

Another Hemet claim to fame was hot, dry summers, perfect for drying apricots. Usually it took three to four days to dry a tray, depending on the humidity and temperatures. If a summer storm developed, everyone rushed to restack the trays. During the 1920s, wages were 10¢ per box for pickers and cutters and 25¢ for hourly work.

Edward L. Mayberry recognized the value of growing potatoes in Hemet after he brought water from Lake Hemet. He suggested that land buyers grow potatoes between the rows of their young orchard trees and make a profit. Another incentive for growing Hemet potatoes was soil storage. When mature, the potato vines could be cut and removed and the potatoes left in the ground until prices were favorable for selling.

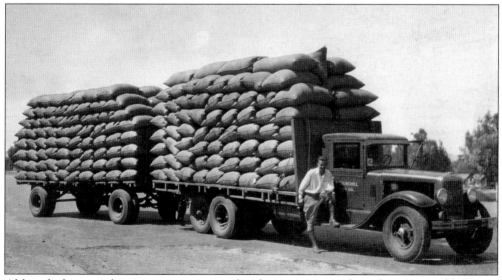

Although they were late in coming compared with potatoes, sugar beets became a viable Hemet product in 1925. Irwin Farrar was responsible for starting this industry, first growing the beets and then cultivating the seeds. In conjunction with Jay C. Loomis, the Farrar-Loomis Seed Company supplied sugar beet seeds to the U.S. and Canadian sugar beet industries.

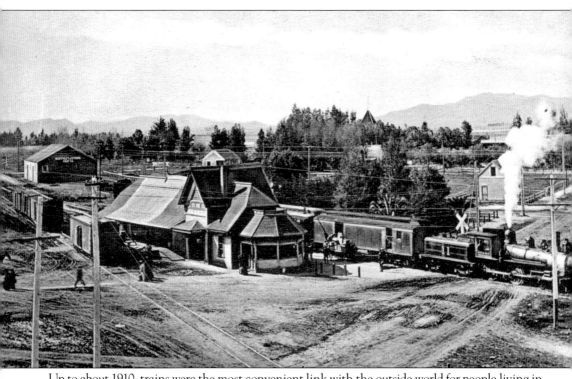

Up to about 1910, trains were the most convenient link with the outside world for people living in Hemet and its surrounding areas. Two scheduled trains per day picked up and delivered passengers, mail, and freight. Sometimes residents did not see each other for weeks except in the passenger cars leaving for or returning from vacations, personal visits, or business trips. The railroad was a spur of the Santa Fe Railroad, which traveled from San Bernardino via Perris and ended at San Jacinto. The depot in this picture was constructed in 1898. The house-looking front portion of the depot was the passenger section with the freight section to the rear. Many times, curious Hemet residents would come to the depot just to experience the whistling and chugging. A livery stable was about 100 yards north from the depot and could serve unmet passengers, and Hotel Hemet was 100 yards south for passengers needing a place to eat and sleep.

Charles McManigal, born 1873, replaced Benjamin R. Sprague as Hemet railroad agent in 1908. Sprague left Hemet to attend medical school in Los Angeles. He returned and practiced medicine for many years, opening the first private hospital in Hemet. Bertie Pearl McManigal, born 1883, assisted her husband as a clerk and telegraph operator. They were a very efficient team at the ornate, red depot at Latham Avenue and Front Street. One day, the railroad agent at Perris sent a telegraphic message to the McManigals asking for a carload rate quote on feathers to be shipped from Hemet to Perris on flat cars. In 1935, Charles McManigal served as president of the Hemet Kiwanis Club. Charles and Pearl retired from their railroad positions in 1944 after 36 years.

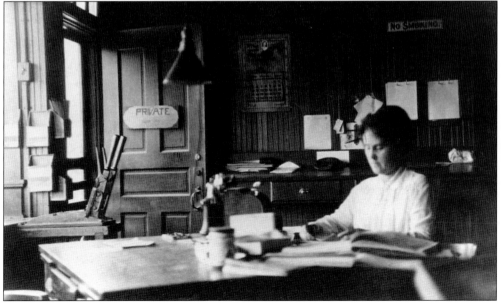

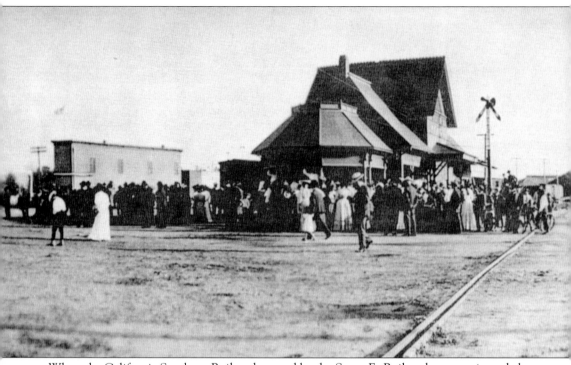

When the California Southern Railroad, owned by the Santa Fe Railroad, procrastinated about building a depot in Hemet, William F. Whittier paid the railroad $250 to build the first Hemet Depot in 1893. This first depot burned down in November 1897, and the railroad company replaced it in 1898 with the depot in this picture. The first depot and subsequent others were located on land donated by Whittier and Edward L. Mayberry to the railroad company. The two-story building to the left of the depot was called the Flatiron Building, constructed by H. Ferguson, who had his real estate office on the ground floor. The second floor was called Ferguson Hall, and it was the scene for many meetings and dances. Cake and ice cream with custard were favorites at the dances. The first moving picture show in Hemet was presented in Ferguson Hall.

Three

BUSINESS AND
GOVERNMENT

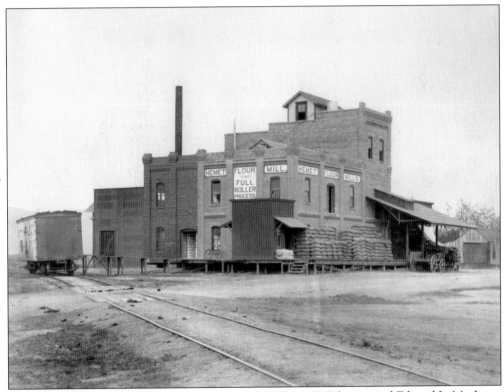

In 1890, William McCool signed a contract with William F. Whittier and Edward L. Mayberry to build a 2.5-story brick, full roller process flour mill. Whittier and Mayberry agreed to give McCool 17 lots adjacent to the California Southern Railroad tracks for the mill and a manager's house. The buildings and equipment, originally called the San Jacinto Valley Flouring Mill, cost $10,000. In 1897, when this picture was taken, Whittier purchased the mill for $4,000 from the State of California for taxes owed and leased it for three years to J. A. Bingham from San Diego, who caused Whittier innumerable problems. After terminating Bingham's lease and having no success in selling the mill, Whittier converted the mill to a power plant in 1903 to generate electricity for the town of Hemet. An April 1918 earthquake destroyed the Hemet Flour Mill building. (Courtesy Swift Collection.)

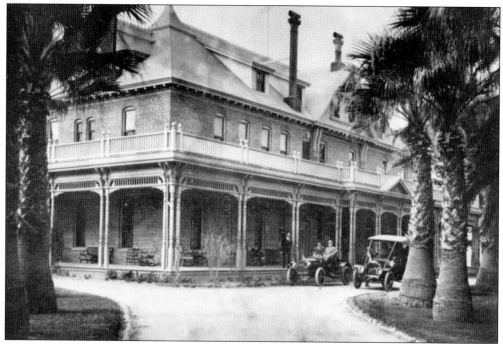

Financed by William F. Whittier, Edward L. Mayberry constructed Hotel Hemet on the southwest corner of Harvard Street and Florida Avenue in 1894. The hotel served the community until 1917 when the top two floors caught fire. The Hemet Fire Department saved the first floor, and visiting women apricot workers used it for two weeks before it too was demolished. (Courtesy Swift Collection.)

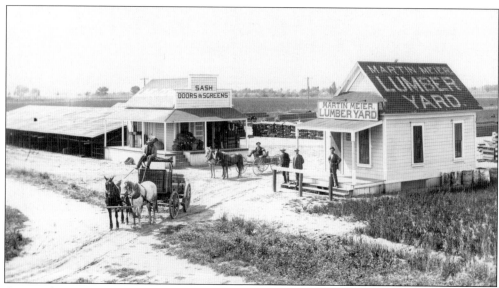

German-born Martin Meier owned a lumberyard in San Jacinto, a business that the young town of Hemet desperately needed. Using financial incentives, William F. Whittier persuaded Meier to relocate his lumberyard to Hemet in 1902 on Devonshire Avenue and Harvard Street. Next to his business, Meier built a house for his family, which still stands on State Street in 2008.

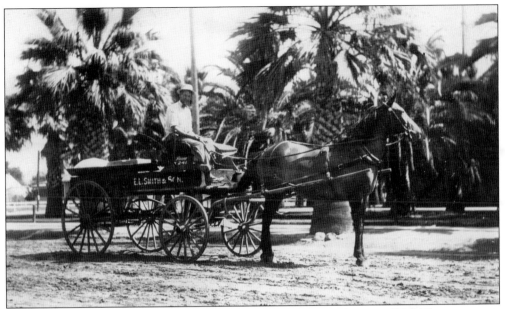

E. L. Smith and Son provided a grocery business for Hemet residents in 1906. Their store was located on north Harvard Street. The firm also delivered groceries by horse and wagon. In this picture, employee Russel Lewis is delivering groceries to Hotel Hemet about 200 yards south of the grocery business. (Courtesy Swift Collection.)

Frederick G. Wedemeyer was the town druggist in 1906, stocking not only drugs but also candies, gifts, and sundries. Wedemeyer's drugstore became very popular in 1910 when he opened the first soda fountain in Hemet. Park Hill Nursery supplied the flowers shown in the picture for the opening day reception. Wedemeyer also sold "medicinal" liquor until the Riverside County sheriff arrested him. (Courtesy Swift Collection.)

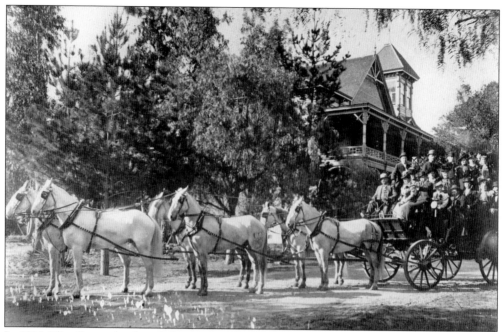

In 1901, Eliza Stone purchased the Fairview Hotel, constructed in 1888 in the town of Florida five miles east of Hemet, and renamed it the Magnolias Hotel. Known for its magnolia trees, the hotel served the best fried chicken in the San Jacinto Valley. The white horse–drawn tallyho in front of the hotel is leaving for a tour of the San Jacinto Valley. (Courtesy Swift Collection.)

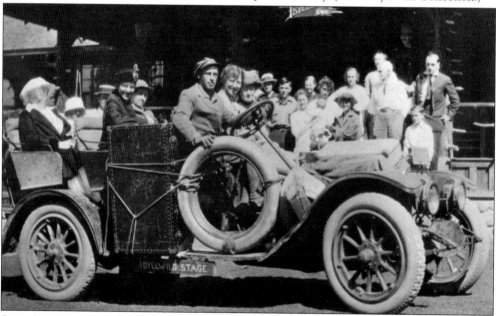

Some Los Angeles physicians founded Idyllwild in the San Jacinto Mountains in 1901. It became a popular summer resort area, especially for those living in the hot San Jacinto Valley. William F. Whittier was the first to start a stagecoach line from Hemet to Idyllwild in 1906 that evolved into a motorized business. The Idyllwild Stage sits in front of the Idyllwild Inn in this picture. (Courtesy Swift Collection.)

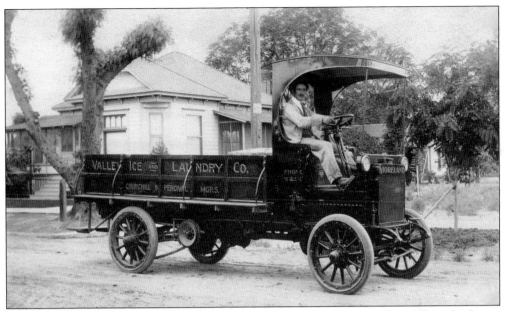

In 1910, J. Oliver Percival came to Hemet and collaborated with Amos Churchill in the Steam Laundry Company, which under Percival became the Valley Ice and Laundry Company, distributing ice and laundering Hemet's clothes. In this picture, Al Silverthorn is piloting the Valley Ice and Laundry chain-driven Moreland Truck. (Courtesy Swift Collection.)

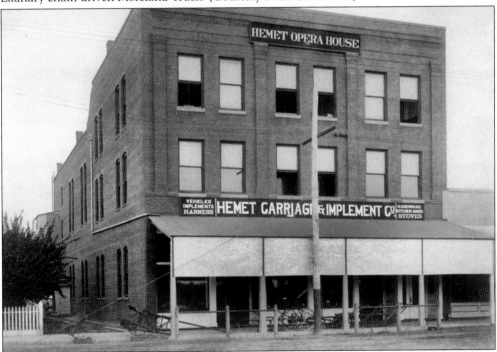

Completed in 1906, the second Hemet Opera House—the first one burned in 1899—opened thanks to William F. Whittier. A large store was on the first floor, a 500-seat auditorium occupied the second floor, and lodge rooms were on the top floor. According to the *Hemet News*, "W. F. Whittier never wearies of doing big things for Hemet."

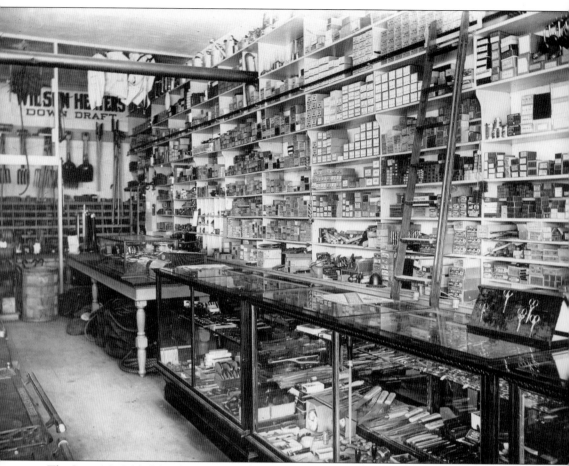

The Isaac M. Gibbel family came to the San Jacinto Valley in 1891 to settle on land southwest of Hemet, build a church, and form a German Baptist congregation, sometimes referred to as the Brethren or Dunkard Church. I. M. had five children; his youngest, Isaac B. Gibbel (called I. B.), was 16 when the family arrived in California. After attending Riverside Business College, I. B. started working in the Hemet Hardware Store. By 1901, he was the proprietor of the Hemet Hardware and Implement Store, located on the northeast corner of Florida Avenue and State Street. He later renamed his business Gibbel Hardware. From the time he started his business until his daughter sold it in 1963, Gibbel Hardware was one of the most popular businesses not only in Hemet but also in the entire valley and mountain regions. There was a saying in Hemet that "if you couldn't get it at Gibbel's you couldn't get it." As the picture indicates, the products in Gibbel Hardware were a montage of all things necessary and desired in a small town.

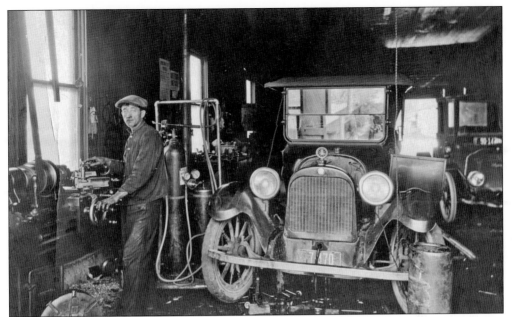

Hayes A. Walker, known as "Happy," is shown in his auto repair business on Front Street. The Hemet City Council appointed him city marshal in 1913 and later chief of police, after the council instructed him to stop his bounty hunting activities. Walker did, but the council fired him in 1929 when he was found taking money from local bootleggers during the Prohibition era. (Courtesy Swift Collection.)

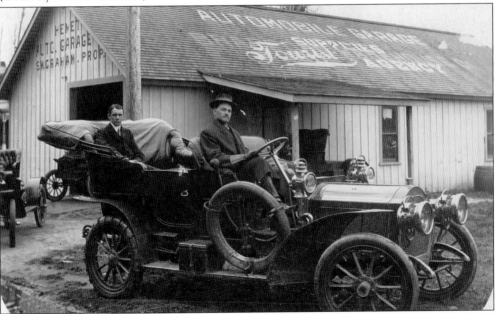

Henry E. Bothin, William F. Whittier's son-in-law, owned this 1906 Model S Packard 24, which cost $6,000. The unidentified passenger and Bothin's chauffer are waiting for the repair of a ruptured tire at S. W. Graham's Hemet Garage. A wealthy San Franciscan, Bothin built an Italian-style mansion on Park Hill in Hemet that he and Whittier's daughter, Lottie Jennie, never occupied. They divorced in 1908. (Courtesy Swift Collection.)

This picture presents employees of the Southern Sierras Power Company, which brought electricity from San Bernardino to Hemet in 1912. This meant a drastic change in lifestyle for people not living in the areas served by the William F. Whittier–owned Hemet Mill and Power Company. The general availability of electricity resulted in electrical wiring in Hemet building and remodeling designs. (Courtesy Swift Collection.)

Owsin and Helen Kellner started the first variety store in Hemet in 1921, moving their business to a north Harvard Street location in 1923. This picture was taken in 1941, two years before Helen Kellner sold the business. Laura Lehman was Helen's niece and eventually married Hemet resident Clarence Swift. The Hemet Museum and the Hemet Library are the grateful beneficiaries of the historic Swift pictorial collection. (Courtesy Swift Collection.)

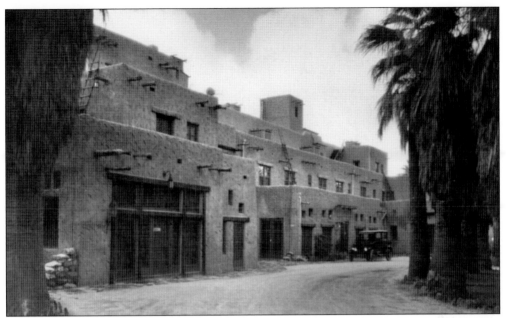

Designed by Edward L. Mayberry Jr., Hotel Alessandro opened in 1929 on the southwest corner of Florida Avenue and Harvard Street on the site originally occupied by Hotel Hemet. The outside looked like a Hopi Indian cliff structure with flat roofs and log ends projecting from the adobe-looking walls. Sixty guest rooms occupied the upper two floors. In 1954, the Alessandro was razed for a Citizens National Bank.

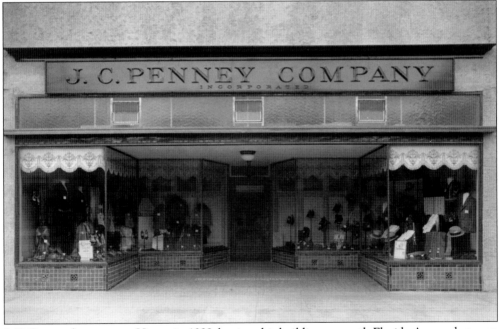

J. C. Penney first came to Hemet in 1929, leasing this building on south Florida Avenue between Carmalita and Juanita Streets. When it opened in July, new dresses with long sleeves or sleeveless dresses were on sale for 98¢. In 1939, J. C. Penney leased the lower floor of the two-story Brudin building on the southeast corner of Florida Avenue and Carmalita Street.

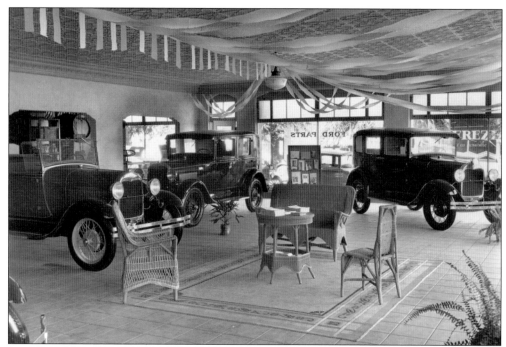

Two corners on Florida Avenue and Juanita Street became quite busy when Ford and Chevrolet dealerships were constructed in 1927. B. C. Bristol and Asa Cox built their new Ford Agency on the southeast corner. The interior shown in this photograph presents wicker furniture, two 1928 Ford Sedans, and a Ford Roadster. The first Model T Ford arrived in Hemet in 1909 when undertaker William Kingham drove his new car from Riverside.

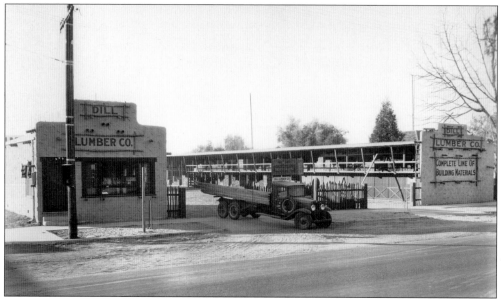

Dill Lumber Company was located on south Florida Avenue just north of the railroad tracks. In its early days, Russell McCoy worked for Dill in the office and eventually left to form the well-known McCoy Lumber Company. Dill Lumber Company's claim to fame occurred in 1940 when it supplied all the lumber for the initial construction of the Ryan School of Aeronautics in Hemet.

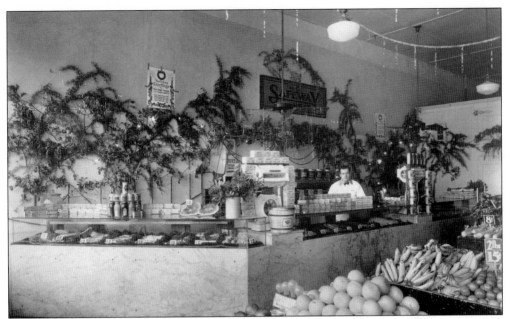

Safeway was the first nationally known grocery company to establish a store in Hemet. In 1927, the grocery store moved to its second location on the south side of Florida Avenue between Carmalita and Juanita Streets. The above picture presents its third location with a grand opening in a brand-new store on the west side of Carmalita Street just south of Florida Avenue. Safeway sold this store building to the *Hemet News*.

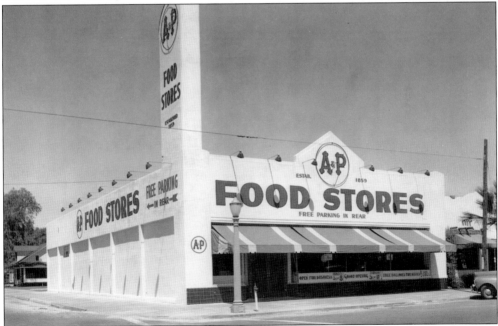

The Hemet A&P Food Store opened in the fall of 1941 on the northeast corner of Florida Avenue and Juanita Street. Its grand opening included a free breakfast of Iris Tomato Juice, Sperry Pancakes, Log Cabin Syrup, and Knudsen's Butter served with hot slices of E-Z Served Meats and A&P Eight O'clock Coffee.

Harvey Gibbel, nephew of I. B. Gibbel, owner of Gibbel's Hardware, owned the Union 76 Station on the southeast corner of Florida Avenue and Buena Vista Street in the second half of the 1940s. Harvey served on the Hemet City Council from 1956 until his death in 1966. After his death, the Hemet City Council established Gibbel Park in honor of the Gibbel family's services to the community.

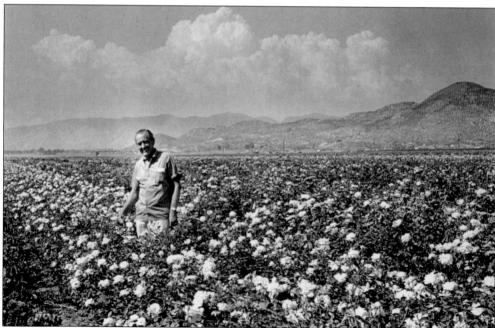

In 1908, Charles W. Howard purchased land from the Hemet Land Company and started the Howard Rose Company. He hired Ernest J. Lindquist to perform propagation and in 1913 named him a partner. In this picture, Robert Lindquist, son of Ernest, is standing in a field of roses planted in 1955 on leased Diamond Valley land, approximately four miles south of Hemet.

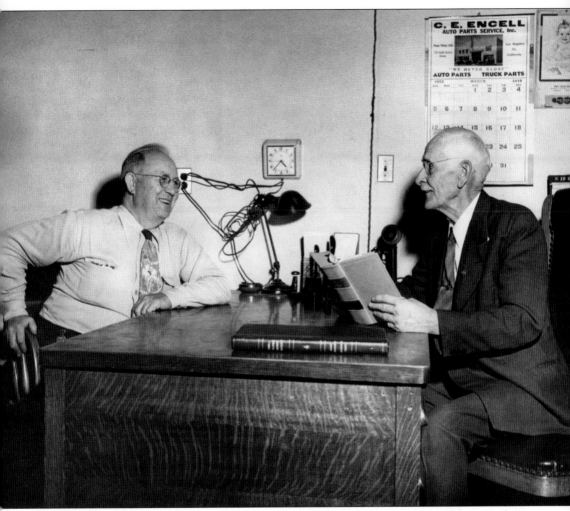

It is 4:37 p.m. on March 29, 1950, and two men are posing for a newspaper reporter/photographer. Justice of the peace for Hemet Township George Sorkness, sitting at his desk on the right, had occupied this position for 20 years. At 75 and in frail health, he decided not to run again and endorsed William W. Evans, in the visitor chair on the left, against Burr Van Housen. Sorkness, known for his tirades on one subject or another through the years, this time blasted the Riverside sheriff and district attorney's "machine" for attempting to remove him from his judgeship. Sorkness announced on March 31, 1950, in the local newspaper that he was endorsing Evans because "he [Evans] will not permit dictators to run his court. In this statement I am sincere." Unfortunately for Sorkness and Evans, Van Housen won the justice of the peace position in the November 1950 Hemet election.

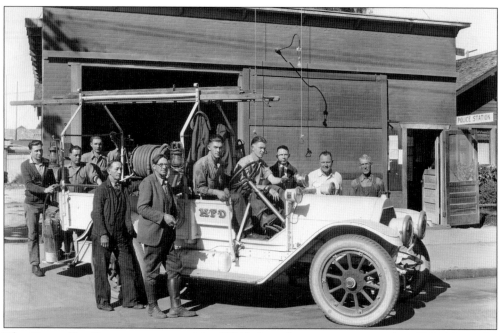

The Hemet Fire Department started in 1907 before the city incorporated in 1910. Then the volunteers became a city department. In 1913, the city purchased a Cadillac chassis and installed a fire truck body on it for the first Hemet fire engine. Longtime fire chief J. H. Spencer, in boots and jacket with cigar in hand, and other volunteers are posing around the first Hemet fire truck.

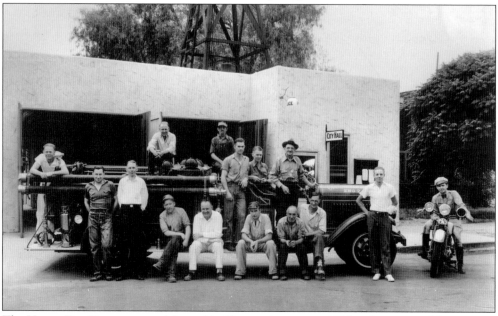

The Hemet Fire Department celebrated its 31st anniversary in 1938 with its second fire engine, a LaFrance Pumper, in front of Hemet City Hall on the west side of north Carmalita Street. At this time, the fire and police departments occupied the same building. Fire chief J. H. Spencer, wearing the felt hat, is standing on the engine running board. Paul Greenleaf was the first motorcycle police officer.

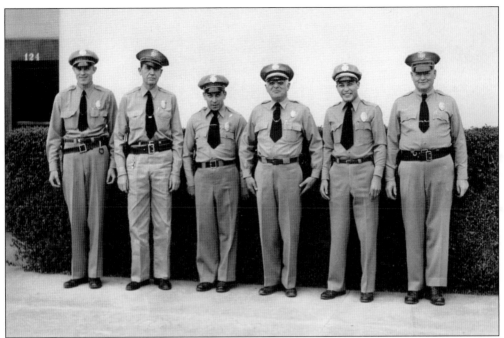

The 1951 Hemet Police Department consisted of six officers with chief of police Cecil W. Walsh and Capt. Nash Terrones, fourth and fifth from the left respectively, in charge. The *Hemet News* printed in 1953, "a six-man police force maintains the peace of the town, and this is provable by the virtual immunity Hemet enjoys from major crime." Hemet's population in 1951 was 3,386.

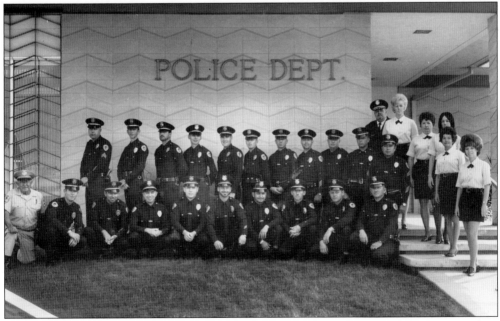

L. D. Pollom, standing behind the blonde-haired woman, was Hemet chief of police in 1972 when this picture was taken. After his appointment in 1969, Pollom made sweeping changes in the department. He restructured the chain of command and switched officers' uniforms from tan to blue and police cars from all white to black and white. Hemet's population in 1972 was 12,252.

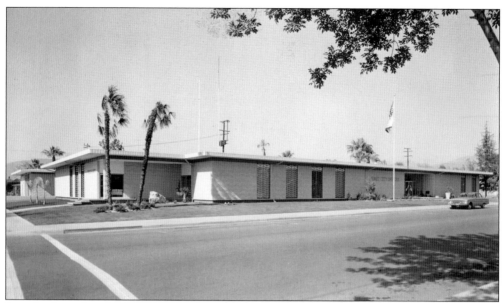

It took a long time, but Hemet finally had a civic center to house city offices and the police and fire departments. Groundbreaking ceremonies for the civic center, costing $245,000, occurred in January 1960, the city's golden anniversary month. The center was located on north Latham Avenue between Juanita and Buena Vista Streets. At the time, James Simpson had been mayor of Hemet for 10 years.

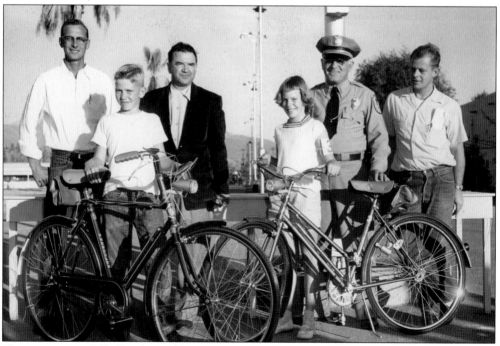

Two youngsters, Billy Franke and Jan Peterson, are proud winners of the City of Hemet Bike Awards in the 1950s, held at the Farmers Fair Grounds. Celebrating with the bike winners are, from left to right, Leonard Searl, Mayor James Simpson, chief of police Cecil W. Walsh, and Gene Smith.

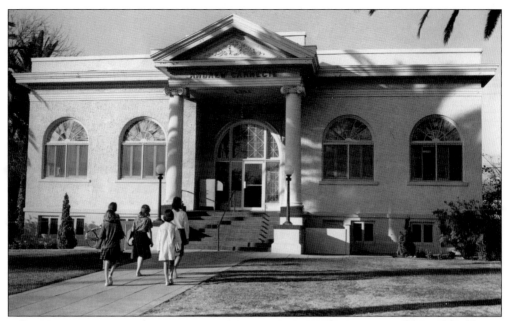

After Hemet incorporated in 1910, over 100 voters petitioned city trustees for a public library. William F. Whittier was opposed, voicing that Hemet could get along without a library. Undaunted, the trustees passed a library ordinance. Andrew Carnegie donated $7,500 for a library building, and the Hemet Woman's club raised $4,500. This Carnegie Library opened in 1913 at the northeast corner of Florida Avenue and Buena Vista Street. (Courtesy Swift Collection.)

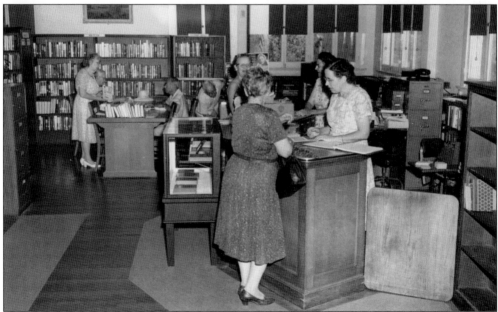

The Carnegie Library building had a main floor and a basement where organizations held meetings. Later the basement served as the Children's Room. The woman wearing white shoes standing in the left rear is Violet Tapper, one of Hemet's finest librarians. The Carnegie Library building served the community until 1965, when earthquake engineers condemned it. The Hemet Woman's Clubhouse served as the library for the next six years.

49

In 1907, C. B. Covell was appointed manager of the Hemet Farmers and Merchants Bank. Covell served on the Hemet Library Board for 27 years. After his death, his heirs established the C. B. Covell Memorial Fund and in 1971 gave $250,000 to the city for a library building, erected on the Carnegie building site and named the C. B. Covell Library.

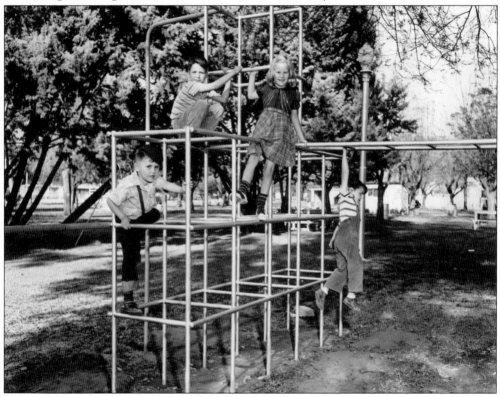

These children are playing on the jungle gym in Weston Park. Dr. John B. Weston and family arrived in Hemet in 1913. A year later, voters elected Weston to the city council, and he served seven years, six as mayor. When he left, he gave five acres to the city for a park. In September 1930, the Hemet City Council named the five acres Weston Park.

After the *Hemet News* published an article about the need for a Hemet hospital, the chamber of commerce assumed leadership for this need. In 1943, after a bond election, the Hemet City Council with the help of a citizen's hospital association built a 14-bed community hospital. This first hospital was designed so that another wing could be added, which it was in 1949.

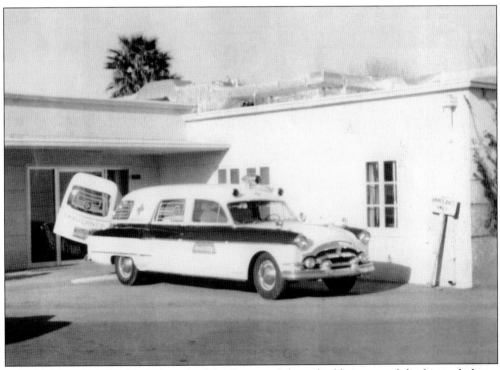

Harford Funeral Home, located north of the Carnegie Library building, started the first ambulance service in Hemet in 1927, first using its hearse and subsequently purchasing this Packard ambulance. Harford operated their ambulance service until 1954 but their funeral home even longer. There was a saying in Hemet that "if you were seriously ill or hurt, Harford would take care of you, one way or another."

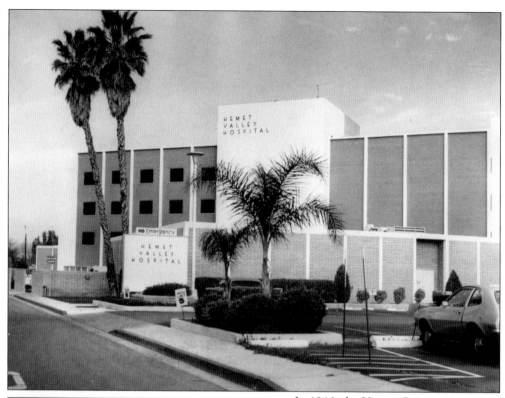

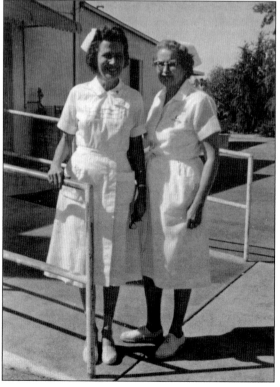

In 1946, the Hemet Community Hospital became Hemet Valley Hospital, governed by the board of directors of the Hemet Valley Hospital District. As this 1973 picture reveals, the little 14-bed 1943 hospital evolved into a giant. As such, it attracted highly qualified physicians and surgeons from all over the world. In addition, it served a growing population both in and outside the San Jacinto Valley.

These two nurses are standing outside Hemet Hospital. On the right is Vera Johansen, who was educated at the L. A. Methodist Hospital School of Nursing. She came to the valley in 1929 and worked at the Soboba Indian General Hospital. Later she worked for the Hemet Community Hospital and Hemet Valley Hospital. When she died in 1970, she was the emergency room supervisor for Hemet Valley Hospital.

Four

SCHOOLS, CHURCHES, PEOPLE, AND RESIDENCES

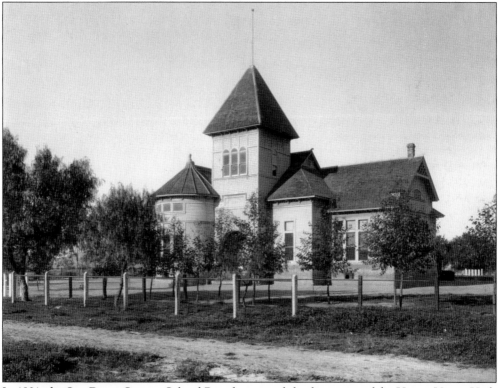

In 1891, the San Diego County School Board approved the formation of the Hemet Union High School District to include the grammar schools in the city of San Jacinto, Old Town San Jacinto, Harmony (a settlement about six miles southwest of the city of San Jacinto), and Diamond School in Diamond Valley. This decision was made even though the little town of Hemet did not have a grammar school. A semblance of a school was held in Mr. Phillip's unoccupied house where Virginia Merritt taught about 20 pupils. At the request of Hemet residents, the Riverside County Board of Supervisors formed a Hemet School District in 1893. The building in this picture is the first Hemet Grammar School, costing $3,000 and consisting of two classrooms, four coatrooms, a large hall, and a bell above the classrooms. The school was located on the northeast corner of Florida Avenue and Alessandro Street. Thirty-seven students attended when it officially opened. Grades one through four occupied one classroom and grades five through eight the other.

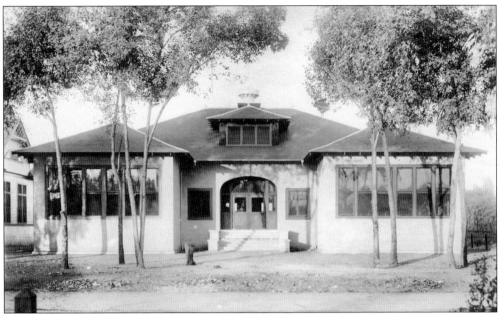

By 1908, the Hemet Grammar School was "stuffed" with students. To relieve the congestion, the school board hired contractor John Plato to renovate this creamery building after it was moved next to and south of the grammar school building, a part of which is on the left in this picture. Grades one through three occupied the original building and grades four through eight the renovated building.

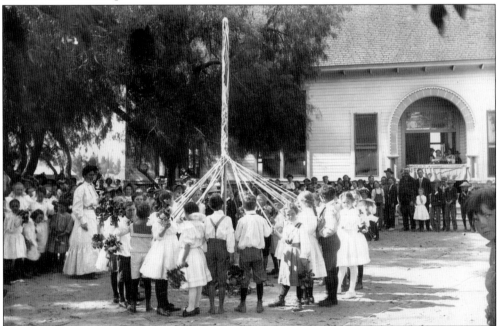

In this picture, Hemet Grammar School students are celebrating May Day, a celebration of spring marked on the first day of May, with a maypole dance in front of the school building. The students hold bright streamers and dance around the pole, weaving the streamers in and out until the pole is decorated.

San Jacinto contractors Hanson and Schale built the first Hemet High School in 1894 on the northwest corner of Acacia Avenue and Buena Vista Street. William F. Whittier bribed Lyman Gregory, Riverside County superintendent of schools, with two free Hemet lots if he located the building in Hemet. This building served not only Hemet but also Diamond Valley, Harmony, Old San Jacinto, and Valle Vista School Districts.

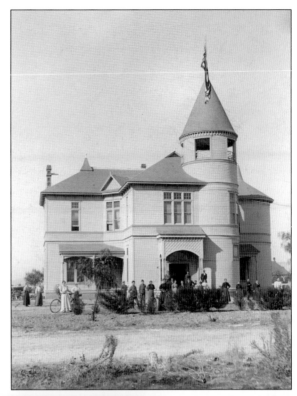

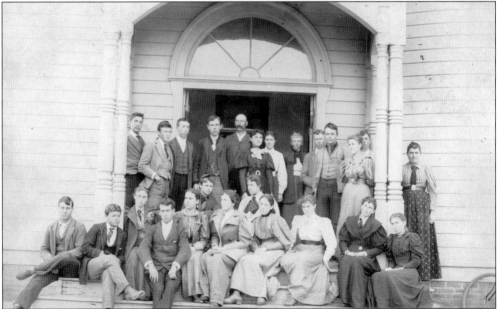

This picture presents the students attending the new Hemet High School in the fall of 1894. The gentleman with a mustache standing in the middle of the last row is Prof. Roger Root, principal. The woman standing to the right of the pole is Miss Compton, teacher. Before this building was constructed, Hemet High School classes were held in San Jacinto under A. W. Plummer, first principal and teacher.

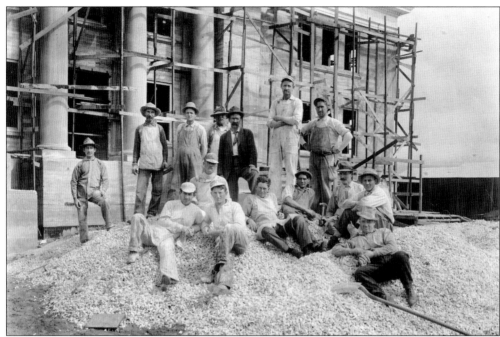

Increased grammar school enrollments in 1908 reverberated to the Union High School, forcing the now eight supporting school districts to pass a bond issue for building a new $25,000 Hemet Union High School. The workers in this photograph are employees of contractors James Martin and his partner P. F. Witter, who started the building in 1910 for a February 1911 opening.

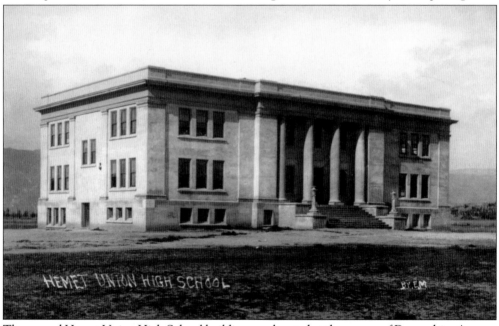

The second Hemet Union High School building was located at the corner of Devonshire Avenue and Santa Fe Street. Principal Edgar T. Boughn moved his office and duties from the old to the new building. It was as though the students attending the new high school took on new life. Hemet Union High School became the leading school in the county in debate and general scholarship.

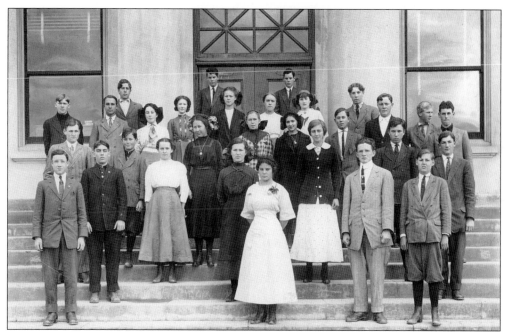

These 30 students are the Hemet Union High School class of 1915, starting their high school adventures in the new 1911 building. Annie Tripp, the student in the all-white dress, attended nursing school after graduation. Glen Brubaker, standing third from the right in the back row with the dark coat and white shirt, stayed in Hemet and became the superintendent of the Hemet Packing Company.

In 1968, seismic studies revealed that the Hemet High School building on Devonshire Avenue and Santa Fe Street was unsafe. District voters approved a bond issue, of which $4.8 million was earmarked for a new high school on 40 acres with a 54-room building to educate students in grades 10, 11, and 12. In 1972, this third "Bulldog" Hemet High School opened on Stetson Avenue and Stanford Street. (Courtesy Hemet High School.)

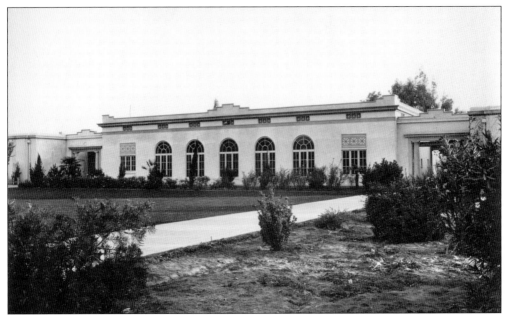

In 1920, the Hemet Union High School District organized an intermediate school for seventh and eighth graders in the manual training building. A year later and directly across the street from the high school, the district built two wings on the manual training building for a junior high school. It was not until 1926 that the junior high school consisted of seventh, eighth, and ninth grades.

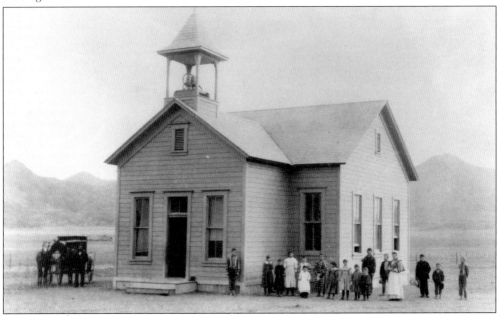

The Hemet Union High School District played a vital role for outlying, small district schools. In 1896, the Helvetia School, a poetic name for Switzerland, was organized in a portion of Pleasant Valley, approximately 15 miles from Hemet. Graduates from Helvetia attended Hemet High School until 1908, when the Helvetia District lapsed and the students attended Perris schools. (Courtesy Swift Collection.)

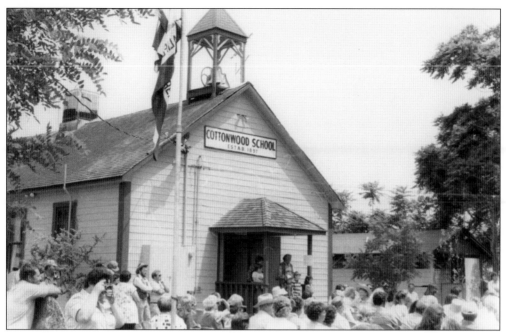

The date on the Cottonwood School sign reads "Estab. 1897." This was the fourth Cottonwood School. Jacob Bergman of Aguanga built the first one-room school in 1870. It burned down and was rebuilt in 1879. The third school was built in 1887. This 1897 Cottonwood School was used until 1975, the last one-room schoolhouse in Riverside County. As late as 1945, Cottonwood School was in the Hemet Union High School District.

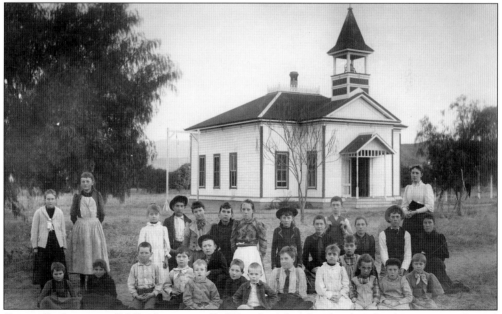

Originally the town of Valle Vista was called Florida. After the Florida School District was formed in 1892, the name was changed to Valle Vista School District. In 1936, this first Valle Vista Elementary School was abandoned and sold and another elementary school was constructed. Valle Vista School District has been part of the Hemet High School District since 1894.

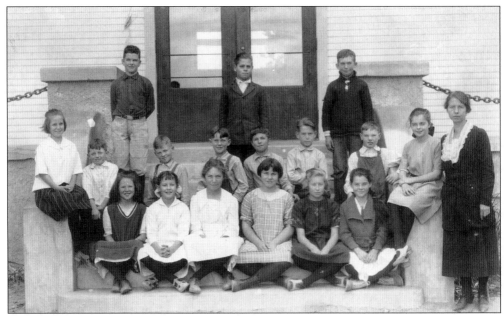

These students and their teacher, Addie Newton, are in front of the Fruitvale Grammar School, located west of the town of Hemet. The first Fruitvale School was constructed in 1896. Hemet contractor Emil Brudin constructed this second two-room Fruitvale School in 1914. Later, when the students were bused to Hemet Elementary School, the Fruitvale Farm Center used the building.

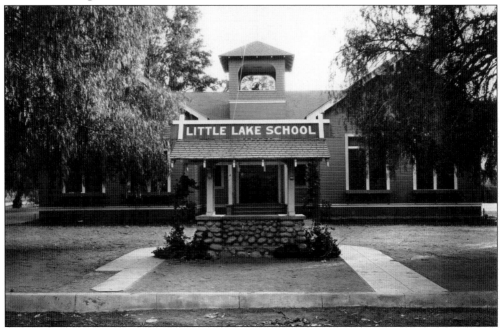

Little Lake School District was formed in 1900. The first district directors purchased land from the Hemet Land Company and rented a building from lumber merchant Martin Meier for the first school building. During the first year, the directors hired contractor W. P. Stump to build a one-room school, which opened in 1901. This picture of the school was taken in 1913.

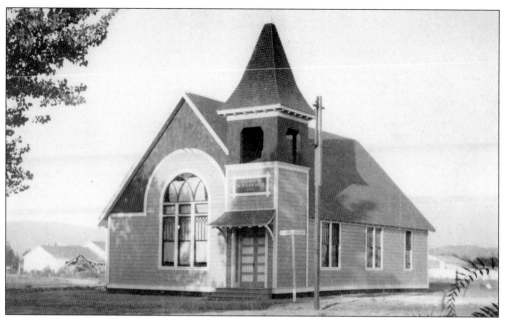

In 1898, Hemet Methodist leaders asked William F. Whittier if he would donate lots for their first church. Whittier agreed with two stipulations. The new Methodist church had to be equal in size to the Baptist church, and members "must have money enough subscribed by reliable parties before the church is commenced." The Methodists built their church in 1902 on two Whittier-donated lots at Carmalita Street and Kimball Avenue.

Emil Brudin constructed this second Church of the Brethren in 1914 on the southwest corner of Inez Street and Acacia Avenue in Hemet. The first Brethren Church was constructed in 1893 at Egan, about eight miles southwest of Hemet, and then moved behind the new Hemet church building. In 1947, the Church of the Brethren ceased to exist and the church building was sold to another congregation.

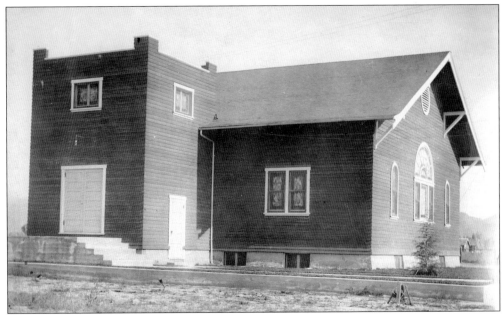

The Hemet Presbyterian Church was organized in 1908, and the congregation held their services in Hemet High School at Buena Vista Street and Acacia Avenue. The membership purchased property at the southeast corner of Buena Vista Street and Kimball Avenue and built their first church in 1910. In 2008, the Hemet Presbyterian Church still occupies its original site with a beautiful sanctuary, meeting rooms, and a recreation hall.

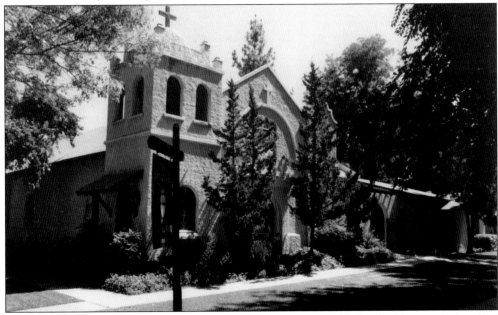

English settlers coming to Hemet, beginning in 1903, were responsible for this Episcopal Church of the Good Shepherd. The membership first purchased two lots from William F. Whittier on south Juanita Street for their church. Later they traded these lots for two at the corner of Carmalita Street and Acacia Avenue. James Martin and P. F. Witter constructed this Spanish-designed building in 1910, and it still stands.

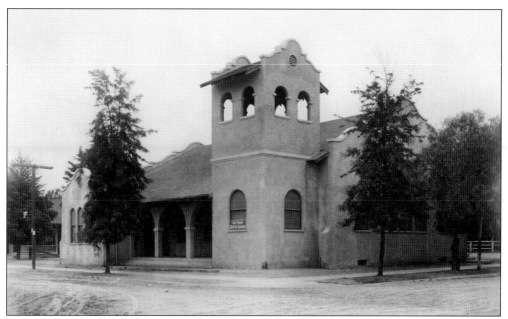

In 1894, the Baptists were the first to organize, building a church in Hemet on two lots donated by William F. Whittier at Harvard Street and Kimball Avenue. Two early Hemet residents, P. C. Little and W. W. Phillips, were proud of it: "We have a Baptist Church, a public school, a high school, and an opera house." The Baptist church in this picture was dedicated in 1912 at the same location as the first church.

This group of well-dressed parishioners is seated and standing in front of their Pilgrim Congregational Church, Church of Christ. The church, built in 1908, is located on property donated by William F. Whittier. When the first Valle Vista Elementary School was abandoned in 1936, the school bell was given to the Pilgrim Church and hung in its belfry. This 1908 church looks like the 2008 church.

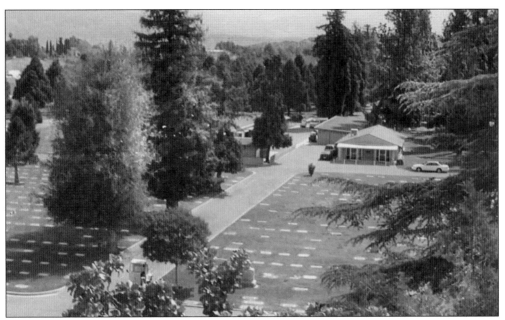

This picture is an aerial view of the San Jacinto Valley Cemetery where lie many of Hemet's former settlers, residents, and leaders. The cemetery was started in 1888, and in 1917, Riverside County took it over and formed a cemetery district. For tax purposes, the district included the following school districts: Diamond, Fruitvale, Harmony, Hemet, Little Lake, San Jacinto, Valle Vista, and Winchester. (Courtesy San Jacinto Valley Cemetery District.)

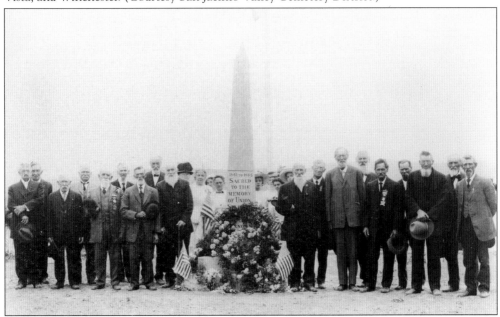

In 1911, Memorial Day services were held at the San Jacinto Valley Cemetery for Civil War veterans. Many of the early Hemet settlers in the 1890s were Union army veterans. They came to Hemet for the availability of work and for health reasons. Levi Morehouse, for example, purchased six acres in 1890 because he thought the Hemet climate would be good for his health. (Courtesy Swift Collection.)

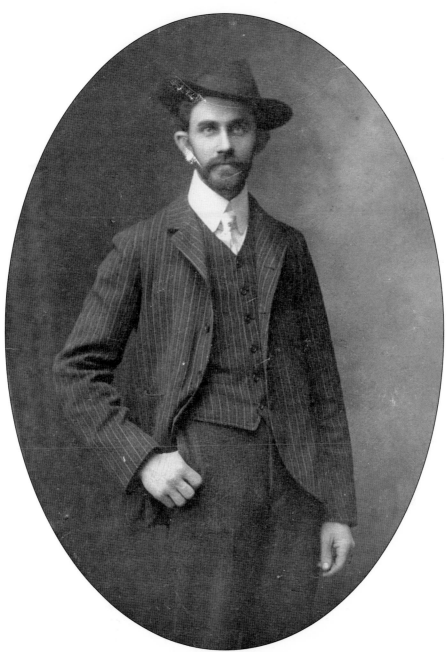

S. I. White, his wife, Jennie, and three sons, Harvey, Forrest, and Raymond, arrived in Hemet in 1905 from New England, joining a number of other New Englanders who settled in the San Jacinto Valley. The White family frequently participated in bean suppers and music and dance programs with their New England friends, most of whom were acquainted with William F. Whittier, also a New Englander. S. I., or Cy as he was called, worked as a rural postal carrier, but his real passion was photography. He was so good that eventually he became the official town photographer. His 1906 picture of water going over the Lake Hemet Dam for the first time since its 1895 construction became a classic. Many of his other photographs appear in this chapter and book. This picture of White was taken in 1915.

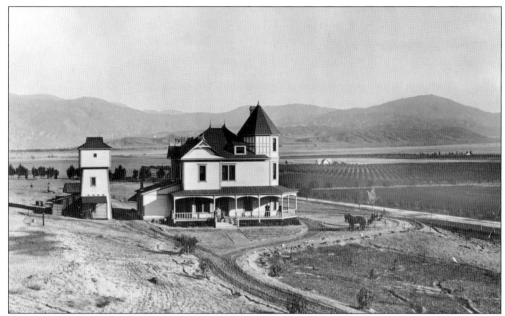

This substantial and palatial three-story Hemet home was built on the southeast slope of Park Hill in 1896 for the Botterell family. John H., his wife, Marianne, sons J. Harry and William, and daughters Annie and May came from Cornwall, England, in 1895. They called their new home Pendennis, which became the civic and social center in the valley with teas, sing-alongs, and the Botterell orchestra. (Courtesy Swift Collection.)

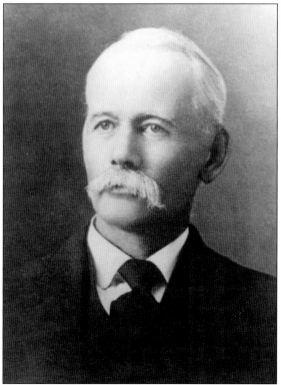

Thomas S. Brown was elected the first mayor of Hemet in 1910 when Hemet became a city. Brown garnered 140 votes, the most of the first five elected city trustees. Brown was 54 years old at the time and worked as a real estate agent. Brown's popularity rose in 1907 during an incorporation meeting when he stated, "We want to cease being a one man town." (Courtesy Swift Collection.)

William B. Tripp is sitting with his wife, Alice Hopkins. His daughter Edith, the first of 12 children, is standing. Before he married, Will drove a Butterfield Stage from San Bernardino to Julian, where he met Alice. The Tripps owned a Hemet butcher shop on north Harvard Street where lamb shanks sold two for 15¢. The Will Tripp family was very popular in Hemet.

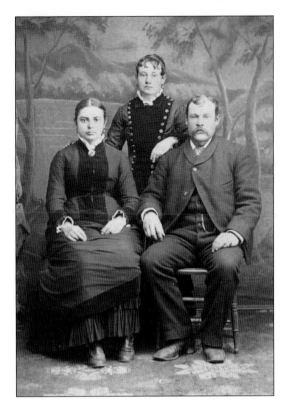

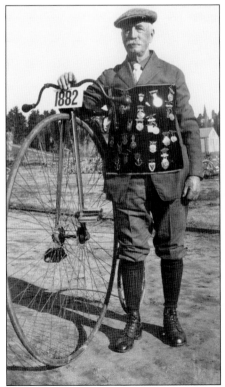

William F. Whittier persuaded building contractor Edward P. Burnham to move to Hemet from New England. In 1906, Burnham built the second Hemet Opera House, and in 1908, Whittier hired Burnham to build the Bank of Hemet on the northeast corner of Harvard Street and Florida Avenue. Burnham is wearing medals he won in the 1880s as a penny-farthing bicycle racer. (Courtesy Swift Collection.)

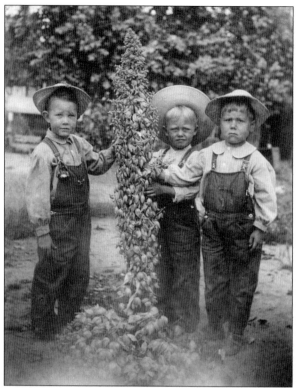

These three serious young men are posing around a huge yucca bloom. They are four years old. Harry White, son of Hemet photographer Cy White, is on the left. Keith Peterson is in the middle, and Darrell Tripp is on the right, the son of William B. Tripp. After Darrell graduated from Hemet High School, he attended medical school and became Dr. Darrell Vinton Tripp. (Courtesy Swift Collection.)

This picture was taken in 1958. Francisco Romero constructed this house in 1887 before William F. Whittier and Edward L. Mayberry moved their town of Hemet to the railroad tracks. Romero worked for Mayberry, digging ditches. Romero's first child, Mary, was the first baby born in what would become Hemet. The house was torn down to make way for the Dill Lumber Company.

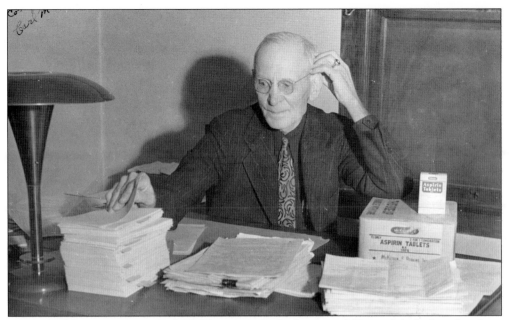

Hemet building contractor Carl M. Thompson built the second Hemet Methodist church in 1918 on the southwest corner of Buena Vista Street and Florida Avenue. In 1928, he won a city council seat and served for eight years. By far the most difficult job he performed was chairman of the Hemet War Price and Rationing Board during World War II. In this picture, Thompson's World War II weariness shows. (Courtesy Swift Collection.)

Hancock M. Johnston is standing with his family, from left to right, Albert Sidney III in Confederate jacket; Hancock Jr.; wife, Mary Alice; daughter Mary ("May"); and John Griffin. Johnston owned 10 percent of the Hemet Land and Lake Hemet Water Companies until William F. Whittier bought his stock after Johnston did not pay his stock assessments. Confederate general Albert Sidney Johnston II, Johnston's father, was killed at Shiloh during the Civil War.

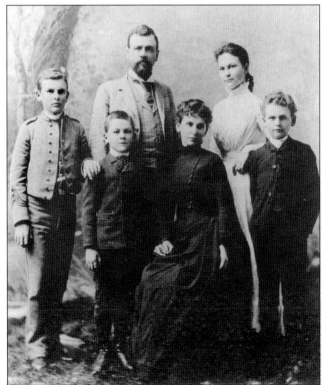

Tommy Rawson graduated from Hemet High School in 1902, riding his bike from Rawson Ranch 20 miles from Hemet. He was known for his thrashing work in the San Jacinto Valley, hiring men such as John L. Lewis, labor leader, and Charles W. Paddock, Olympic runner. In this 1920 picture with his Essex, Rawson always wore the same outfit—tan clothes, necktie, puttees, and ranger-style hat. (Courtesy Swift Collection.)

No other man provided as much leadership to the city of Hemet as James Simpson. Appointed to the city council in 1947, he served until 1968. During these 21 years, he was mayor for 18 years, guiding the city from an agricultural to a retirement-based community. Hilltop Simpson Park was named in his honor, and a community center was dedicated the James Simpson Memorial Center.

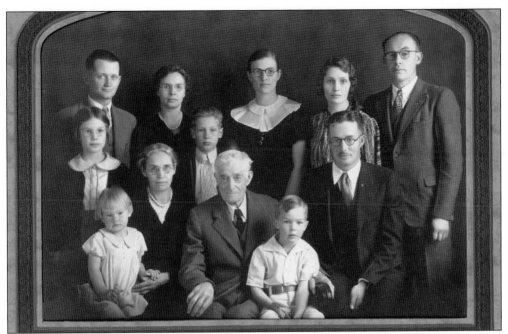

Jacob and Anne Schideler and their three children arrived in Hemet in 1913, purchasing five acres on east Central Avenue. Their three children attended Hemet schools and earned college degrees. In this family portrait, Jacob and Anne are seated in front with two of their grandchildren. Jacob was the last surviving Civil War veteran in Hemet when he died in 1937 at 94 years.

The *Hemet News* wrote in June 1939 that the new Nelson residence was one of the finest constructed in the valley. Earl Ballou built this house on south Latham Avenue east of Buena Vista Street for Ed and Sadie Nelson, owners of a clothing store on north Harvard Street. While the house was being constructed, the Nelsons celebrated with a new granddaughter, Susan Scranton, and then later they greeted Betty Scranton, their second granddaughter.

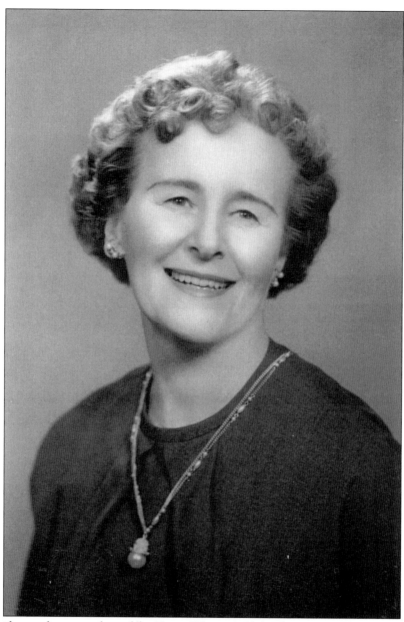

Laura Swift served as a president of the Hemet Woman's Club. The Hemet Woman's Club is older than the City of Hemet. Thirteen women desiring to discuss current topics formed the club in 1906. The next year, the club changed its purpose to community service and its name to the Hemet Woman's Club. One of the club's first and finest accomplished service projects was establishing a Hemet Library. In 1917, the club purchased a lot next to the library for its clubhouse and in 1927 opened its new clubhouse, considered one of the finest buildings in Southern California. In 1923, club members made many of the costumes for the first performance of the Ramona Pageant. During World War II, the club held dances for Ryan Aeronautic School students and other servicemen. Another public service for the community was given in 1974 when Hemet Woman's Club president Laura Swift held the first general meeting to organize the Hemet Area Museum Association.

Five

HEMET STOCK FARM, RAMONA PAGEANT, AND FARMERS FAIR

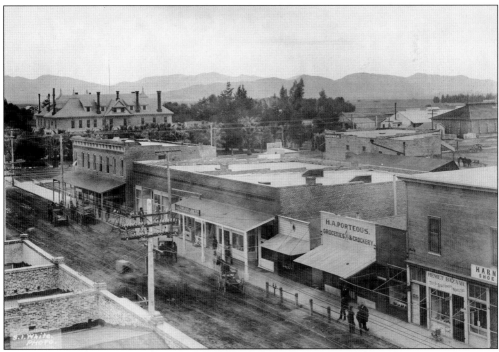

This is what downtown Hemet looked like in 1909: dirt streets with telephone and electricity poles. This picture was taken from the third floor of the Hemet Opera House on the east side of north Harvard Street, the main drag. The roof of the three-story Hotel Hemet can be seen in the upper part of this picture surrounded by trees. The last building on the west (right) side of Harvard Street is the Farmers and Merchants Bank building, owned by William F. Whittier's son-in-law Henry E. Bothin. Directly across the street on the northeast corner is the Bank of Hemet, owned by Whittier. The building on the lower extreme right is the two-story Ferguson Flatiron Building. In between the banks and the opera house and Flatiron buildings were grocery, dry goods, hardware, bakery, jewelry, stationery, real estate, water company, furniture, shoe, barbershop, and clothing stores, all sustaining a growing community. What is unseen in this picture is the Hemet Stock Farm, an entity that made Hemet unique in all of California.

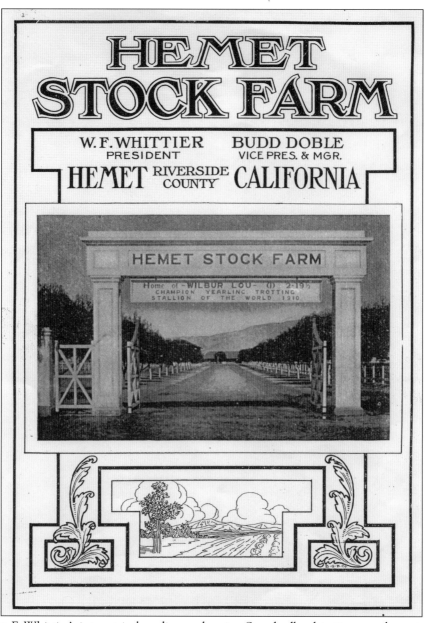

HEMET STOCK FARM

W. F. WHITTIER
PRESIDENT

BUDD DOBLE
VICE PRES. & MGR.

HEMET RIVERSIDE COUNTY **CALIFORNIA**

HEMET STOCK FARM

Home of -WILBUR LOU- (1) 2·19½
CHAMPION YEARLING TROTTING
STALLION OF THE WORLD 1910

William F. Whittier's interest in breeding and racing Standardbred trotters was long-standing. When Edward L. Mayberry died in 1902, Whittier took charge of his string of trotters and started thinking about constructing a racetrack on Hemet lands. He hired Frank H. Holloway, an expert on racetracks, to come to Hemet and among other things construct a half-mile track on a 40-acre parcel only a few minutes' walk from the railroad depot. The 1906 San Francisco earthquake delayed Whittier's plans, but by 1909, the Hemet Stock Farm became a beautiful reality, bounded by Oakland Avenue on the north, Gilbert Street on the west, Devonshire Avenue on the south, and State Street on the east. This gate, constructed in 1910 on Devonshire Avenue, announced the entrance to the stock farm and the championship performance of Wilbur Lou, Whittier's yearling-stallion trotter. Born at the stock farm in 1909 and sired by Kinney Lou out of dam Louise Carter, Wilbur Lou was named by Holloway after his deceased son Wilbur Frank.

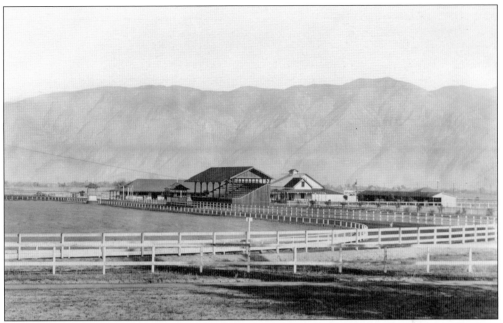

This is the Hemet Stock Farm in 1910, looking northeast to the San Jacinto Mountains. The farm is not quite finished; a coat of whitewash paint had not been applied to the 300-seat grandstand. Behind and under the grandstand was a waging room where bets were made and winners paid. The 30-foot-wide, half-mile racetrack is in the foreground. The manager's office is directly behind the grandstand.

The manager's office had a prior history. Edward L. Mayberry built a bunkhouse in 1887 on the north side of Park Hill for men working at the South San Jacinto town site. The bunkhouse was moved to Hemet in 1892 and used to house Hemet workers. In 1909, the building was moved to the stock farm. It still stands and is the oldest building in the city of Hemet.

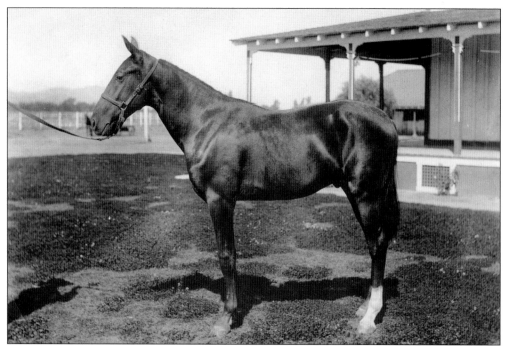

In 1910, Frank Holloway took Wilbur Lou to Phoenix to race in the Pacific Breeder's Stakes. Holloway drove Wilbur Lou's sulky, and William F. Whittier went along for the ride, so to speak. Wilbur Lou beat the yearling-stallion world record at 2:19½ minutes. This was 3½ seconds faster than the world record. Suddenly the Hemet Stock Farm became the home of a world champion.

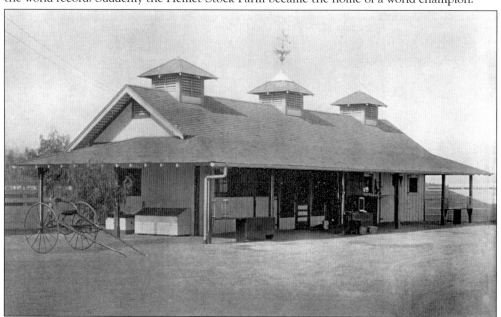

To show him off, William F. Whittier had a barn built especially for Wilbur Lou at the stock farm, consisting of two stalls and a man's sleeping room in between. Ventilators were installed on the top of the stalls and room. Whittier also had a weathervane made, showing a trotting horse, and had the vane installed on top of Wilbur Lou's barn.

Frank Holloway died suddenly in June 1911 while racing Wilbur Lou in Northern California. William F. Whittier quickly hired Budd Doble to take charge of his horses and the stock farm. Doble was 68 and a world-renowned trotting driver/breeder. He owned and raced Goldsmith Maid and Nancy Hanks and broke records. Of Doble, Oliver Wendell Holmes wrote, "Budd Doble, whose catarrhal name so fills the nasal trump of fame."

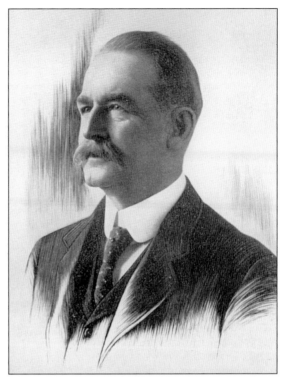

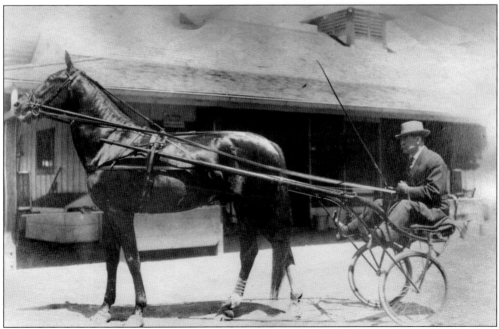

Under Budd Doble, Wilbur Lou won the 1911 California State Fair Futurity in 2:19 minutes, a record again. When Doble brought Wilbur Lou back to Hemet, William F. Whittier appointed him Hemet Stock Farm vice president, general manager, and trainer. When Whittier died in 1917, Doble resigned from these positions. In 1922, Henry Delaney bought Wilbur Lou and took him to New Zealand. Doble died in 1926.

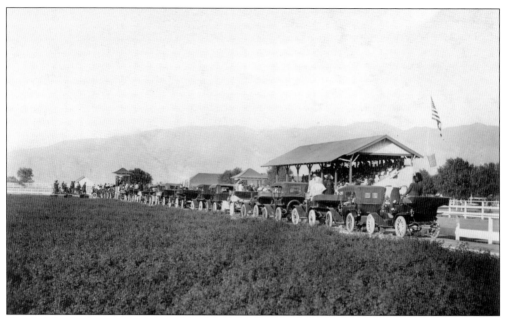

The half-mile racetrack at the Hemet Stock Farm was not only used for racing trotters but also for racing motorcycles. In a letter to his secretary in 1909, William F. Whittier wrote, "On Thanksgiving Day, they had a motorcycle race here and I never saw so many people together in Hemet as there was at that time. There must have been 25 or 30 automobiles around the track and at least 1500 to 2000 people. The races were a great success. Hemet has improved very much." Early on, other events took place at the stock farm, where a Deperdussin monoplane landed in 1913 and motion pictures were filmed. In 2003, part of the motion picture *Seabiscuit* was filmed at the stock farm. The farm also held the Sierra Stampede Rodeo with bronco riding, barrel racing, roping, and other horse events.

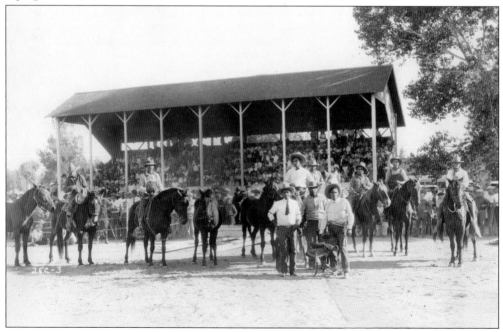

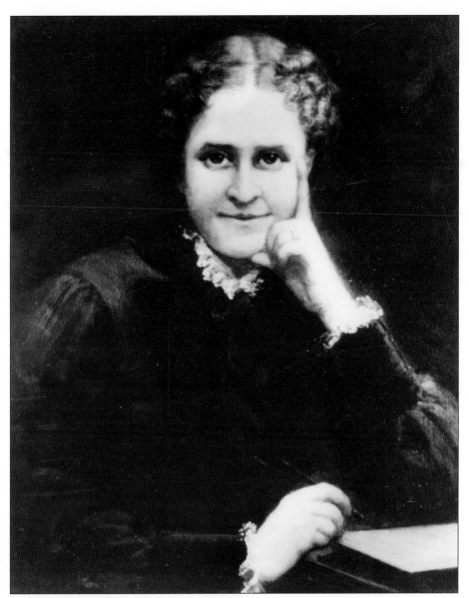

In 1881–1882, Helen Hunt Jackson visited Southern California as a representative of *Century Magazine* to research and write articles about Mission Indians. She was so appalled with what she found that she started bombarding Washington, D.C., officials with reports about the American Indian's plight in Southern California. Because of her personal fight, Pres. Chester A. Arthur appointed Jackson special commissioner of Indian Affairs in Southern California, the first woman given a government commission. Jackson returned to Southern California in 1883 to visit American Indian reservations and submitted her report to Congress, which ignored the report. Upset about Congress's treatment of the Mission Indians, Jackson decided to write a book about Ramona Lubo and her husband, Juan Diego, who was shot and killed for taking a white man's horse. During the white man's trial, the judge dismissed the case. American Indians were not allowed to testify in court. After her 1884 novel, *Ramona*, was published, the public was so incensed about the treatment of the American Indians that Congress made many changes to help them. Jackson died in 1885.

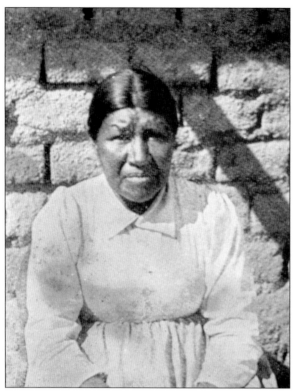

This is elderly Ramona Lubo, wife of Juan Diego. Although Helen Hunt Jackson's *Ramona* was fictional, she adopted Ramona Lubo's story as the basis for her novel about the mistreatment of American Indians. In her novel, Jackson substituted the name Alessandro for Juan Diego. Ramona Lubo died in 1922 and is buried next to Juan in the Cahuilla Indian Cemetery. (Courtesy Swift Collection.)

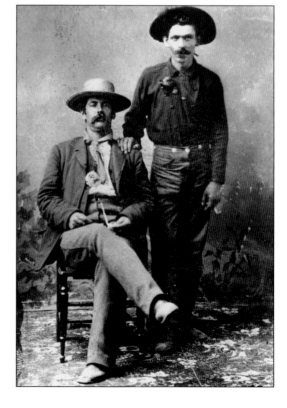

The man sitting is Sam Temple, who killed Juan Diego for stealing his horse. His close friend is Frank Wellman, whose wife gunned him down when Wellman tried to kill her. Temple worked as a teamster, hauling lumber from the San Jacinto Mountains to the San Jacinto Valley. Temple and Wellman enjoyed their liquor. Helen Hunt Jackson named Temple Jim Farrar in her novel. (Courtesy Swift Collection.)

In 1923, the Hemet and San Jacinto communities decided to present Helen Hunt Jackson's novel as an outdoor play. A painted canvas over a wooden frame was made to look like a ranch house. The play was named the Ramona Pageant. Except for the Ramona and Alessandro actors, San Jacinto Valley volunteers acted in the play. Garnet Holme adapted Jackson's novel and served as the first director.

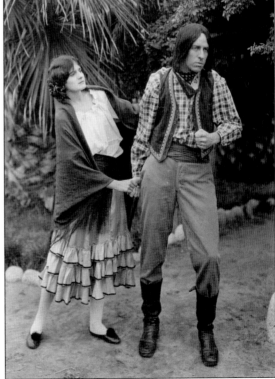

Dorise Schukow and Bruce Botteler, professional Los Angeles actors, played the first Ramona and Alessandro at the ranch house set. The first performances were held on Friday, Saturday, and Sunday in April and the admission price was $1, with 50¢ for children under 14. The play ran each year until 1933, when it was cancelled because of the Great Depression. It resumed in 1934.

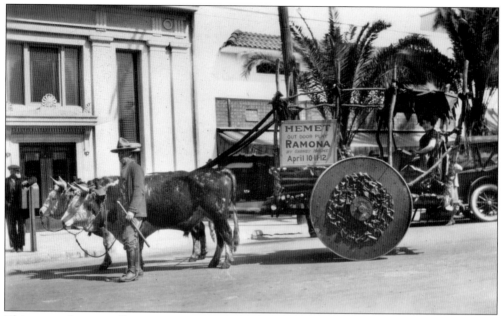

This team of oxen, pulling a carreta, traveled to Southern California cities in 1923, 1924, and 1925 to advertise the pageant. Louis Terra Haute was in charge of the carreta. Total attendance for the 1923 three-day performance was 4,500. The first pageant presentation made a profit of $301.52. In 1926, concrete seats were added to the 1,200 bleacher seats.

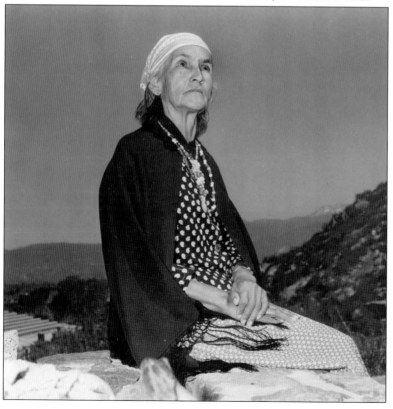

Isadore Costo played the speaking part of Mara, a venerated and aged American Indian woman, in the 1923 Ramona Pageant and for an additional 29 years. She retired from the pageant in 1962. She was a full-blooded American Indian and lived on the Cahuilla Indian Reservation in the San Jacinto Mountains.

The number of Ramona Pageant cast members grew over the years. In 1923, one hundred people performed as cast members. Four hundred people are in this 1992 cast picture in front of the rancho set. The canvas rancho was now a substantial set. A year after this picture was taken, the California Legislature designated the Ramona Pageant as the official California State Outdoor Play.

Aside from Ramona and Alessandro, Señora Moreno, matriarch of the rancho, and her son Felipe are two major speaking roles. In this 1940 picture, Janet Scott played Señora Moreno, her fifth appearance in the role, and Harry Hofmann played Felipe. This was not his first participation. As a Boy Scout, Hofmann cut the trails for spectators to climb the rocky hillsides and witness the 1923 performance.

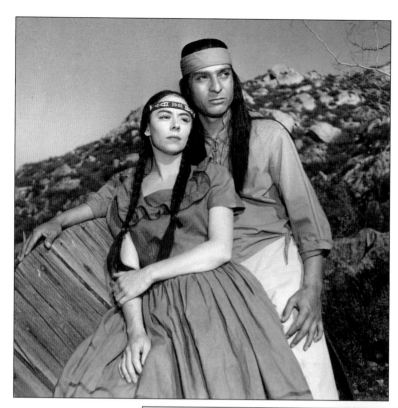

Dorothy Bailey Vosburg started playing Ramona in 1951 while a student at UCLA and continued to do so for the next 10 years. Maurice Jara played the first "singing Alessandro" in 1952, ending his Alessandro career in 1966. In 1965, Jara and his wife, Hilda, an accomplished actress, were named codirectors of the Ramona Pageant and continued to direct until they retired in 1994.

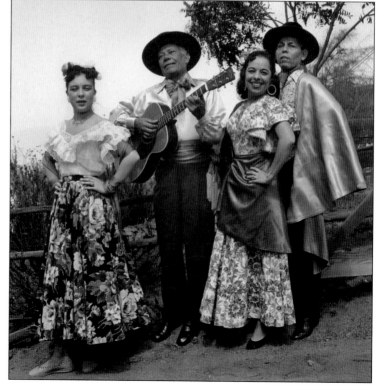

Only the Ramona Pageant can exceed the longevity of Jose Arias and his Troubadours, who started playing during the 1924 pageant season. As the pageant years rolled on, each Arias generation followed suit. In this picture, first-generation Jose Arias is playing guitar for three of his singers and dancers. The Ramona Pageant venue is also used for the Ramona Bowl Music Association summer concerts and plays.

The Hemet–San Jacinto Chamber of Commerce started a beauty contest in which Miss Hemet and Miss San Jacinto were selected queens. The contest in 1947 went so well that it became an annual event. Dorothy (nicknamed Dodi) Scott, on the right, and Betty Mills were named Miss Hemet and Miss San Jacinto, respectively, in 1949. In this picture, both winners were hoping to catch a ride to the fair. In 1936, Jay C. Loomis was in the turkey business and started the Hemet Utility Turkey Show at his warehouse on north Harvard Street. This show became so well known that it was expanded to a Riverside County fair, called the Farmers Fair and Festival, sponsored by the California 46th District Agricultural Association. During five days in August 1949, the fair was held on a 40-acre site at the southeast corner of Florida Avenue and Palm Street in Hemet.

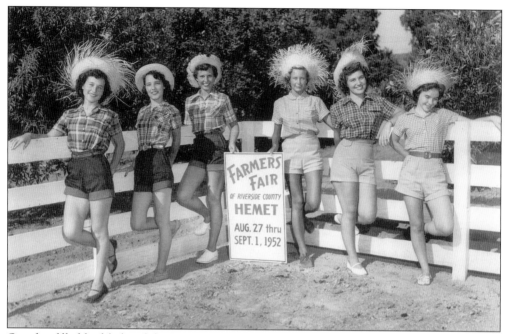

One fun-filled highlight of the Farmers Fair was the Farmer's Daughter competition, in which young ladies competed in daily contests with the winner being named Farmer's Daughter on the last day of the fair. The eliminating competitions included, among other things, tractor driving, sewing, milking, fish cleaning, cooking, and cow herding.

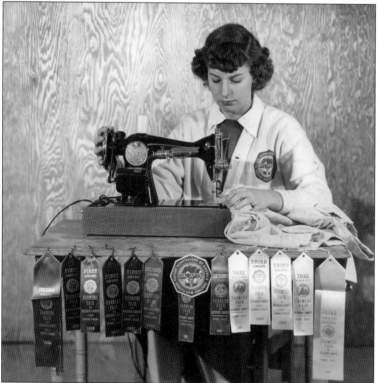

The badge on Donna Smith's white sweater says that she is a Future Homemakers of America member. The 13 ribbons shown were awarded to Donna and other members of her FHA chapter in 1952.

Bill Todt, called "Pitchfork Pete of the Fair," and Farmer's Daughter contestants are standing by and sitting on bales of straw. The young ladies represent Riverside County cities. On the left side of the first row is Bettie Iwerson of Hemet, and standing beside Pitchfork Pete is Pat Privett from Elsinore, who won the Farmer's Daughter Contest that year.

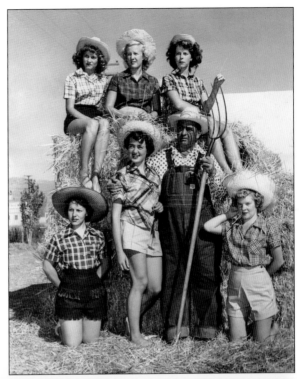

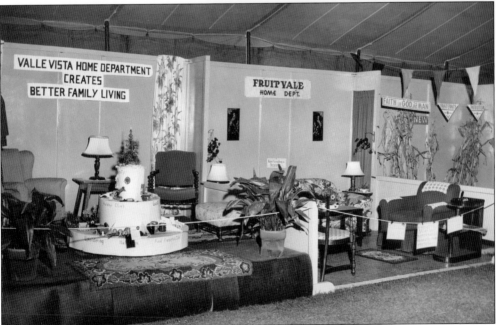

Whether it was the excitement of a carnival midway, the viewing of prized livestock or agricultural exhibits, or the expectation of winning a ribbon in the countless judged competitions, everyone found their particular interest in participating in the Farmers Fair. This included two Hemet-area communities—one east, Valle Vista, and one west, Fruitvale, and their blue-ribbon Home Department exhibits.

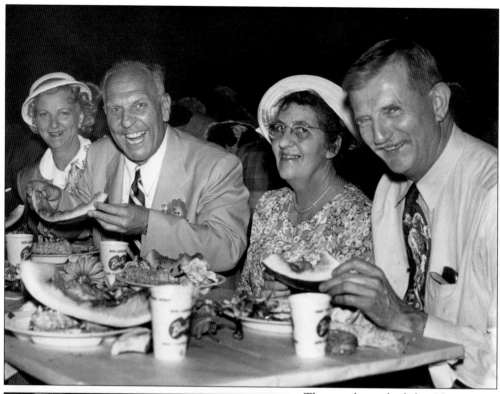

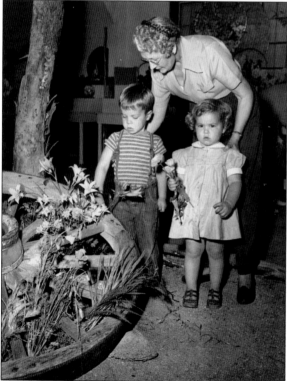

The couple on the left is Virginia and California governor Goodwin Knight and on the right Lillian and state senator Nelson Dilworth from Hemet. Knight was invited to be the guest speaker at the 1953 Farmers Fair. That same year, he succeeded to the governorship when Earl Warren resigned to become the chief justice of the United States, and he also married Virginia, his second wife.

Mrs. C. B. Henry, chairman of the Farmers Fair Flower Show, is showing a wooden wagon wheel with flowers to two young children. The young gentleman is David, and the Shirley Temple–looking young lady is Peggy, who is more interested in the camera than the wheel. They were the children of Dr. and Mrs. W. R. Williams.

These five Farmer's Daughters are showing off the winner of the corn-growing contest at the 1976 Farmers Fair. Arkansas won the national championship with a 10-foot, 4-and-one-half-inch cornstalk, grown at the fairgrounds with good Hemet water. A Minnesota cornstalk also competed but came up short.

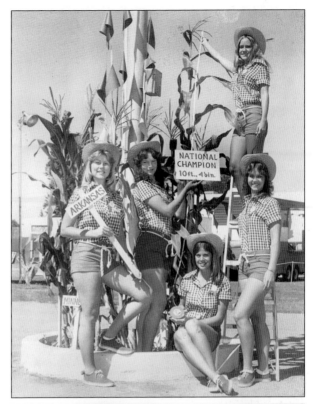

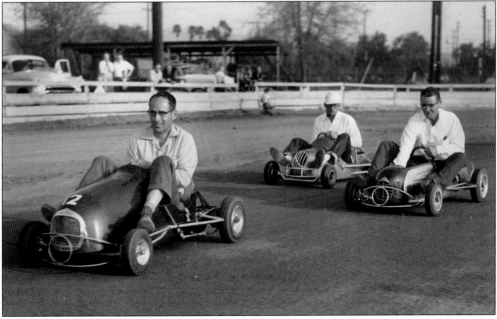

In addition to exhibits of animals, agriculture, foods, flowers, and 1,000 other things, the Farmers Fair held midget automobile races on a real track, supposedly for little people. In 1953, Max Harford (left, from Harford Funeral Home), Jim Ishmael (center), and Dick Evans (right) were trying out the track. Somehow they were able to keep their legs from causing a drag race.

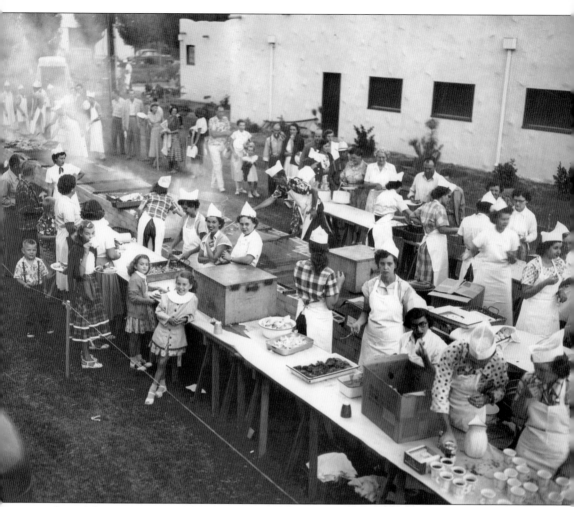

One of the most outstanding Hemet community service organizations was the junior chamber of commerce (Jaycees) and auxiliary. In 1951, they organized and sponsored the first annual Hemet Christmas Parade, which is still held but sorrowfully without the Jaycees' sponsorship and work. During the 1951 Farmers Fair, the Jaycees and Auxiliary held the first chicken barbeque dinner. The following year, the Jaycees set up their barbeques on the north side of the fairgrounds next to Florida Avenue. The aroma alone would have enticed those going by on Florida Avenue to stop and partake of barbequed chicken, baked potato, roast ear of corn, salad, watermelon, and coffee or lemonade. In this picture, the Jaycees men are cooking the chicken in the upper left corner and fairgoers are lined up on the right of the chefs for food served by the Jaycees Auxiliary women.

Six

HEMET-RYAN AIRFIELD AND THE NATIONAL GUARD

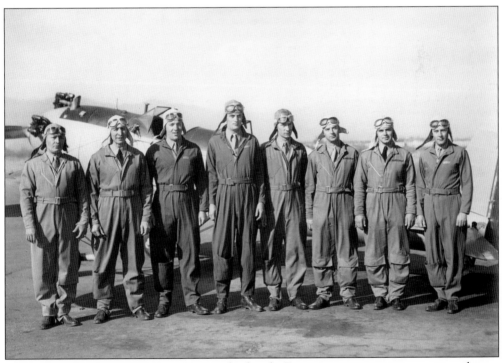

Although the United States was not yet involved in the European war, preparations were underway in early 1940 for possible involvement. Attempting to save time, Pres. Franklin D. Roosevelt and the War Department decided to establish pilot training schools across the country and hire civilians, rather than use army personnel, to teach primary flight training. T. Claude Ryan, owner of the Ryan Aeronautical Company in San Diego, was asked to start such a school and selected Hemet for three reasons: unpopulated areas, little or no fog, and many acres of open land for a main airfield and auxiliary fields for practicing takeoffs and landings. These eight men were the first flight instructors for the Ryan School of Aeronautics in Hemet. These instructors came from all parts of the United States and discovered that they did not have to fight "Old Man Winter"; Hemet was a pilot's Shangri-la. By December 7, 1941, the Ryan School of Aeronautics was going full-blast, training pilots for World War II.

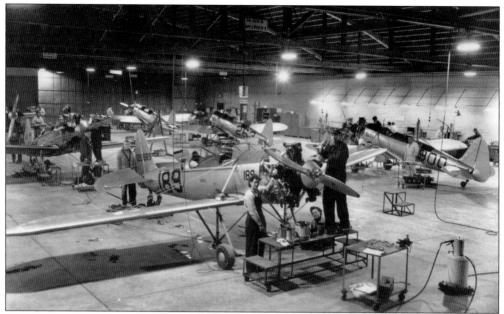

Five hangers were eventually built at the Ryan School of Aeronautics. Constructed by the Ryan Company in San Diego, the first instructional planes were Ryan PT-13 trainers. They were two-seaters with controls and instruments in both cockpits. The instructor occupied the front cockpit and communicated with the student by a Gossport tube. New, more up-to-date training planes were added during the war years.

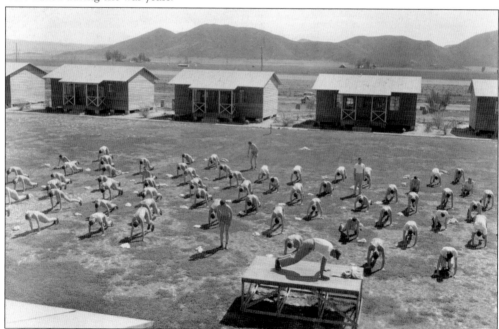

An Army Air Force PT instructor is taking these cadet pilots through an outdoor exercise routine in front of their barracks. Each barrack housed eight cadets. Eventually 55 barrack buildings were constructed. After the war, one of these instructors, Roy Cooper, became the Hemet High School football coach, and the barracks were rented to veterans and their families.

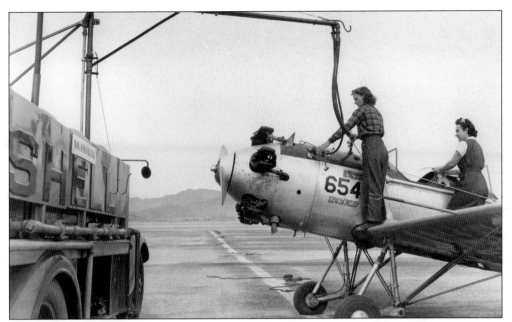

During World War II, no human roles changed as much as those for women. While men went to war or to work in defense factories, women picked up the men's responsibilities, not only in the home but also in traditionally male-oriented jobs. These two San Jacinto Valley women are loading fuel in this Ryan training plane from the Shell gasoline truck. Note the plane's two cockpits.

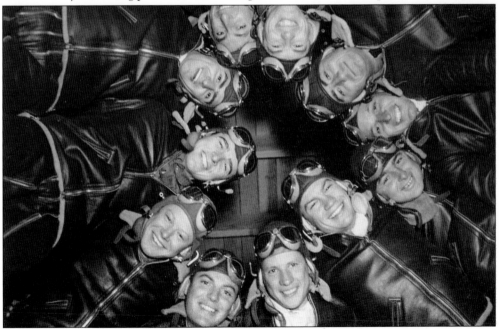

These young pilots just finished their 10-week primary flight training at the Ryan School of Aeronautics in Hemet. They were immediately sent to Randolph Field in Texas, the "West Point of the Air," where they learned fighter techniques. The first class that graduated from Ryan and then Randolph were sent to the Philippines, and all 15 died defending the islands when Japan attacked.

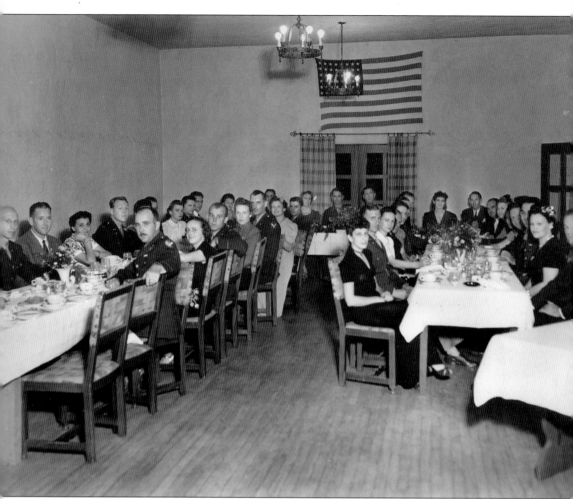

This was the first mess hall at the Ryan School of Aeronautics in 1940. Later it was enlarged, as were the entire facilities, to seat 400 people. This picture is of a party for Army Air Force officers, Ryan civil employees, and their wives. After dinner, the tables were moved and everyone danced to Herb Lewis and his San Bernardino orchestra. Over the almost four and a half years that the school operated in Hemet, many social events, not only for personnel but also for the community, were held in the mess hall. When Ryan School was dedicated in September 1940, some 6,000 people attended the ceremony and the Ryan Company invited 100 special guests to a luncheon in this mess hall. In December 1944, the Ryan School for Aeronautics discontinued operations in Hemet. Eventually all the facilities were given to Riverside County, and the county established the Hemet-Ryan Airfield. Since then, the field has been a vital part of Hemet, used first for crop dusting and now for aerial tankers fighting fires in the mountains and for private users.

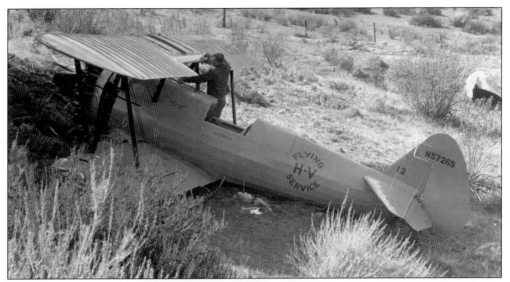

This Stearman, owned by the Hemet Valley Flying Service, was crop-dusting when it ran "aground." It was the practice in crop-dusting to fly low and slow to get the "dust" into the crops. One time, pilot Lloyd Venable struck an embankment of an obscured reservoir. The plane turned upside down, then landed right side up on the opposite side of the reservoir. Venable walked away.

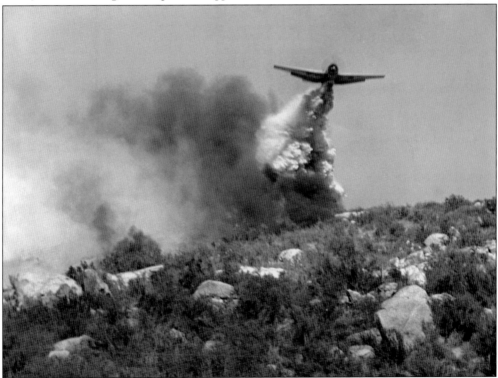

This aerial tanker took off from Hemet-Ryan field with a load of water. The pilot released the flood on a portion of the fire, as seen from the smoke. In the early days of firefighting, loaded tankers also assisted Hemet firefighters by putting out fires in surrounding hills. If a person were on the ground and looked up to the plane, he could identify the pilot.

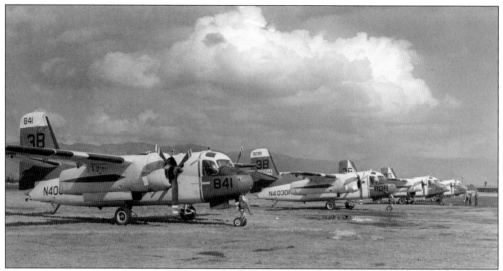

These planes were the beginning of the S-2 Air Tanker Fleet, brought to Hemet in 1973 by the Hemet Valley Flying Service. The U.S. Navy originally used these planes as antisubmarine aircraft. Eventually 19 of these planes became the fleet of the California Department of Forestry, housed at Hemet-Ryan Airfield. They fought fires over all of Southern California and elsewhere.

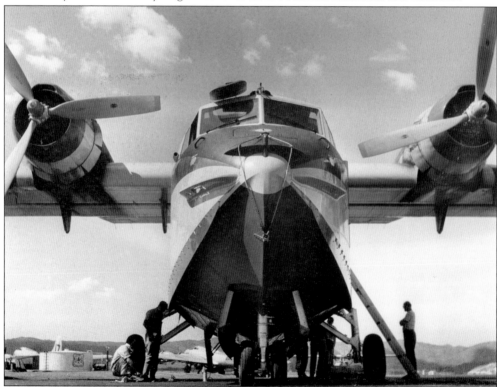

This was an experimental Canadair Super-scooper tanker plane at Hemet-Ryan Airfield. The plane fought fires in the mountains using water available in mountain lakes large enough for the plane to land; the plane would scoop water into its belly, take off, and drop its load on a fire. When water-dropping helicopters became popular, the Super-scooper was of limited use.

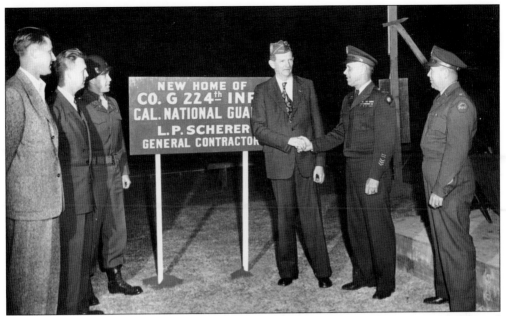

In March 1947, a California National Guard Company was activated in Hemet, designated Company G, Second Battalion, 244th Infantry of the 40th Division. Former California state senator Nelson Dilworth from Hemet, standing on the right side of the sign, is congratulating members of Company G on the forthcoming construction of their new armory. Dilworth served a total of 24 years in the California Assembly and Senate.

These men are practicing drilling techniques in the new $90,000 Company G National Guard Armory located on the Farmers Fairgrounds at Florida Avenue and Palm Avenue. Construction was completed in 1950. At that time, Company G was composed of 84 men and 4 officers from Hemet, Idyllwild, and Perris. Each national guardsman was paid based on attendance and the army rank pay scale.

In June 1950, the United Nations authorized its member nations to help South Korea repel a North Korean invasion. In September 1950, Company G was called to active duty and arrived in Japan in March 1951. These three Hemet National Guard soldiers are having a cool beer on a warm beach at Camp Haugen, Japan. From left to right are Bob Sheppard, Benny Helms, and Webb Ross.

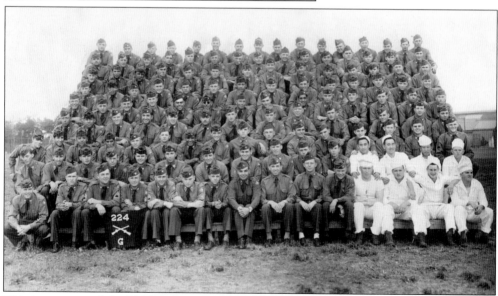

This is a picture of the 224th Infantry Battalion of the 40th Division, Company G, in Japan. The white-dressed soldiers are company cooks. Company G stayed in Yokohama, Japan, for 11 months and then went to Korea in February 1952.

Company G soldier John K. Gresham shared these two photographs with the Hemet Museum. He is in winter garb in Korea, where it was biting cold. Although Korea is in the same latitude as Northern Africa and Southern Spain, in the winter, it is much colder than Stockholm, Sweden. All the soldiers were issued special shoes for winter-wear to withstand snow and cold. They were called Shoepacs, consisting of a rubber foot, leather tops, and felt insoles. Gresham (on the right in the bottom picture) is with another soldier working on a recoilless rifle, used against enemy tanks. It looks like Gresham is cleaning out the barrel of this antitank gun.

Sfc. Melvin E. George, Star Route, Hemet, (left) and MSgt. Edwin Hargey, Idyllwild, pack everything they own into their duffle bags and prepare to head for home as the 40th Division, Company G, starts its "phase out" operation. Starting in April 1952, Company G soldiers returned to California in groups of four and five. By July, all Company G personnel were home.

Sfc. Melvin E. George of Hemet is turning in his heavy winter clothing before checking out. George and other members of Company G spent three months at the Korean front. Only one original Company G man, Arthur Duke, was killed in action in Korea. He died, however, after joining the 1st Cavalry Division. No Company G man was physically disabled, but many were wounded.

Seven

ORGANIZATIONS AND RETIREMENT

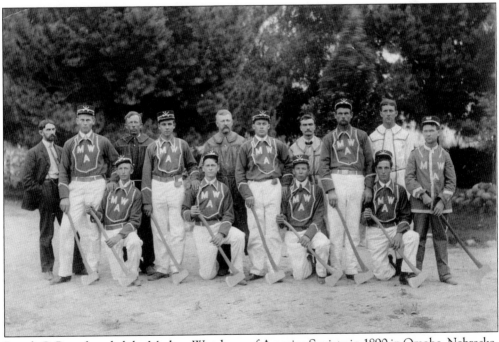

Joseph C. Root founded the Modern Woodmen of America Society in 1890 in Omaha, Nebraska. The purpose of the Woodmen society was to ease the problems of financial insecurity for members, especially funeral expenses. One of the enduring legacies of the society was the distinctive headstones in the shapes of tree stumps. This practice continued until the 1920s, when the headstones became too expensive. These 14 men are the charter members of the Hemet Woodmen of America Society in the San Jacinto Valley Cemetery in 1907. Note that each of the members in the first row is holding an axe, symbolizing building the headstones that looked like stumps. S. I. White, Hemet photographer, is standing on the left wearing the business suit.

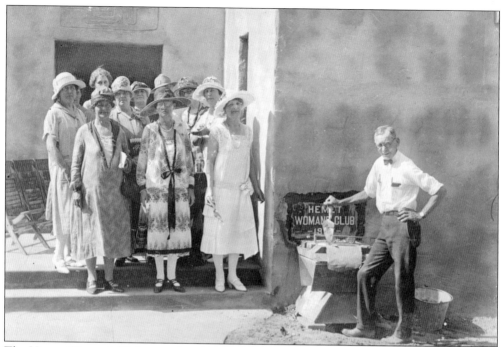

The Hemet Woman's Club started in 1906 with 13 members. This picture was taken when the membership totaled over 100. These 10 members are standing at the front entrance to the new clubhouse watching a worker install a plaque on the side of the building, announcing "HEMET WOMAN'S CLUB 1927." The purpose of the club was to provide community services, and for over 100 years, the Woman's Club provided money and volunteer time for the betterment of the community. This included the preservation of the Hemet Maze Stone and giving the Hemet Fire Department a "jaws of life." In November 1927, American Legion Post No. 53 held a cabaret dance on Armistice Day in the clubhouse, and according to the *Hemet News,* "a grand time was had by all."

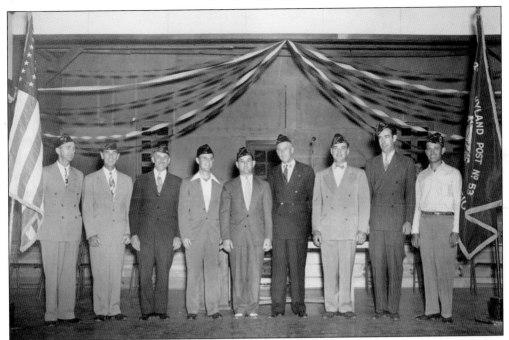

During World War I, Harold Wilson Hyland was the only Hemet resident killed in the war. Born in Weymouth, Massachusetts, he was 26 years old and teaching chemistry at Hemet High School before he enlisted in the army in October 1917. Lieutenant Hyland was killed in September 1918 on the St. Mihiel battle line and buried in the Oisne-Aisne American Cemetery at Fere-en-Tardenois, France. After the war, Hemet veterans formed the Harold W. Hyland American Legion Post No. 53 in honor of Lieutenant Hyland. Soon after the formation of the legion, the American Auxiliary Post No. 53 was formed, consisting of wives and daughters of veterans. These 1940 pictures present the elected officers of the Harold W. Hyland American Legion Post and Auxiliary No. 53.

During World War II, Hemet organizations were formed to help residents deal with wartime problems. One organization was this nutritional group taught by a registered nurse. The picture of these 30 students was taken in Weston Park, and teacher Lucia Ellithorpe is seated third from the right in the second row. Hemet superintendent of schools E. G. Garrison is standing on the left end of the last row.

Bill Watson (standing), manager of the Citizens National Bank in Hemet, greets these Caballeros, who are member of the Riverside County Sheriff's Posse and participated in the Ramona Outdoor Pageant. Among the riders is Virgil Maddox (third from the left in a plaid shirt), who played Hayton in the play and had the honor of being named Riverside County Horseman of the Year.

The Hemet Odd Fellows Lodge started in 1904, and two years later the Comfort Rebekahs Auxiliary was organized. For years, both organizations held many building fund activities. Finally the first two-story Odd Fellows Temple was constructed in 1927 at 136 South Harvard Street, which still stands in 2008. Both groups work on community benefit projects. This picture of the Noble Grands for both organizations was taken in 1954.

These five men eating a 1954 noon dinner represent the Hemet and San Jacinto Chambers of Commerce. From left to right are Walter Lyell, president of the Hemet Chamber; Clayton Record Jr., agricultural chairman of the San Jacinto Chamber; George Orme, chairman of the Citizens Advisory Planning Board; H. E. Devine, president of the San Jacinto Chamber; and G. Roger Brubaker, agricultural chairman of the Hemet Chamber.

The nearby mountains drew Hemet nimrods to the annual deer-hunting season, lasting one month each fall. To prepare for the season, the Hemet Rifle and Pistol Club held a running deer target match on the Searl Ranch in Diamond Valley. A wooden deer attached to running lines with a bull's-eye served as the target. Charlie Reed won the trophy and the two others holding rifles came in second and third.

The woman standing in this picture is Grace Weston, who came to Hemet with her mother, father, sisters, and brother in 1913–1914. Never has one individual done so much for the Hemet community as Grace Weston. She served on the Hemet Welfare Association, Hemet Red Cross, and the state Emergency Relief Association during the Great Depression. She continued her Hemet Welfare work until she died in 1964.

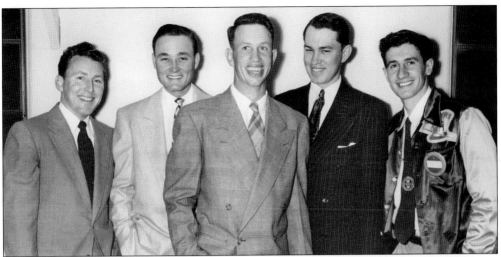

During the 1930s, a group of young Hemet men gathered weekly at noon and during luncheons invited local leaders to talk about and discuss national and local problems. Eventually local problems became primary, and the group started the Hemet 20-30 Club, made up of men from age 20 to 39 who wished to serve their community. The five new officers of the club in 1955 were (above), from left to right, Jack Reisland, Tom Hamblin, Hugh Houk, Dave Trumpy, and Pat Collier. One Hemet service the 20-30 Club provided was to conduct Bicycle Safety Programs for elementary school bike owners. Below, from left to right, (kneeling) Bud Perry and Hugh Houk; (standing) Pat Collier and Dave Trumpy are inspecting and repairing bikes.

Girl Scouting started in Hemet in 1922 when Nora Durrenberger organized the first Hemet Girl Scout Troop. The early Scouts were very active in community services, such as babysitting, planting flowers at the Ramona Bowl, watering flowers at the Hemet Woman's Club, and helping with memorial services at the cemetery. In the 1940s, Gertrude Howard donated property at 331 South Taylor Street, and building contractor Elmo Heavin built a clubhouse, called the "Little House," for the Hemet Girl Scouts. The Hemet Girl Scouts dedicated their "Little House" in February 1948. With the addition of a second room, the Little House continues to serve the Hemet Girl Scouts in 2008.

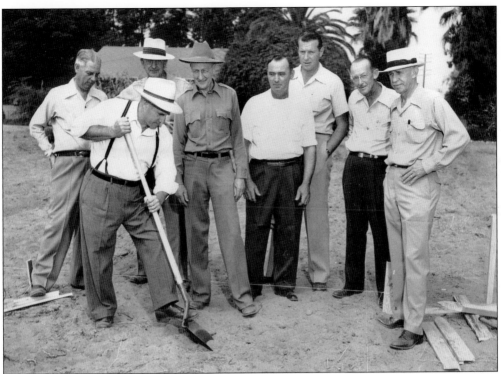

Col. L. L. Koontz, formerly commanding officer of Riverside March Airfield and a member of the Benevolent and Protective Order of Elks, retired to Hemet with his wife after World War II. Soon after moving to Hemet, Colonel and Mrs. Koontz donated a 160-by-200-foot lot for the Elks Lodge No. 1740. In February 1948, the Elks held a party to celebrate the ground-breaking for its $30,000 new clubhouse. The building, housing a beautiful interior with a huge fireplace, was located on the south side of Florida Avenue between Elk and Lyon Streets and continues to be so.

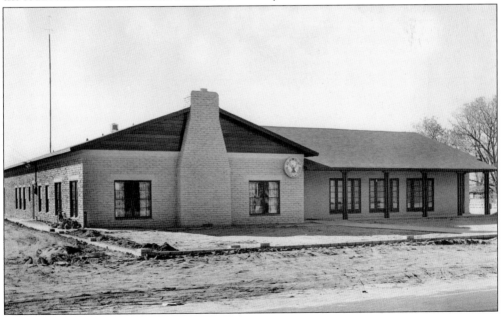

A small group of women related to the members of the Hemet Elks Lodge No. 1740 decided to form an affiliated club of the Supreme Emblem Club. In 1949, their charter was granted and the first officers were elected to serve the Hemet Emblem Club No. 162. They held their meetings and activities in the new Elks Lodge. This picture presents a group of Emblem Club officers elected in the 1950s.

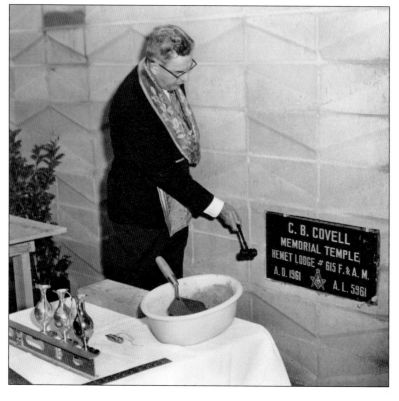

In 1925, twenty-five men petitioned the Worthy Grand Master for the State of California to start a Masonic Lodge in Hemet. On October 15, 1925, Masonic Lodge No. 615 received its charter. By 1928, the Hemet Lodge had 66 members. In 1961, the Masonic Lodge celebrated its new C. B. Covell Memorial Temple after the directors of the C. B. Covell Memorial Fund gave money for the new building.

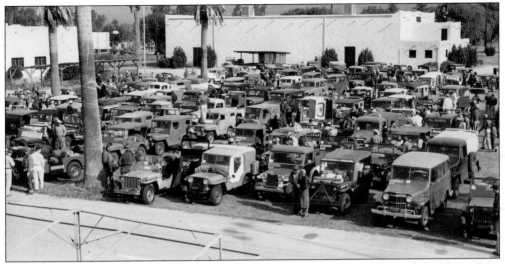

In 1948, Ruth Peters, manager of the Hemet Chamber of Commerce, organized the Hemet Jeep Club and the first Jeep Cavalcade. Many of the first members were World War II veterans who owned military jeeps, such as Ruth's husband, Karl. In this 1954 picture, jeepers gathered at the Hemet Farmers Fairgrounds prior to starting out on their annual cavalcade, which was usually to the Anza-Borrego Desert area.

These four-wheel-drive World War II–issued jeeps are participating in the first cavalcade and came to a standstill when the trail bosses tried to confuse each other in Collins Valley, the northern entry to Anza-Borrego. These 1948 trail bosses are lost. In true American style, the group on the left won out because of its superior numbers.

During the 1948 cavalcade, the jeepers used an old remnant of a 1935-era Civilian Conservation Corps (CCC) road built through Coyote Canyon to cross the flowing Coyote Creek, again in Anza-Borrego. This first jeep cavalcade was held in the spring. In another two to three months, the creek bed would be dry.

This jeep cavalcade picture shows a four-wheel-drive truck on the right that carried supplies for the cavalcade. The shadows reveal that it is still early in the morning at Split Mountain (see rear mountain view) in Anza-Borrego. It looks like portable kerosene stoves are ready to boil water.

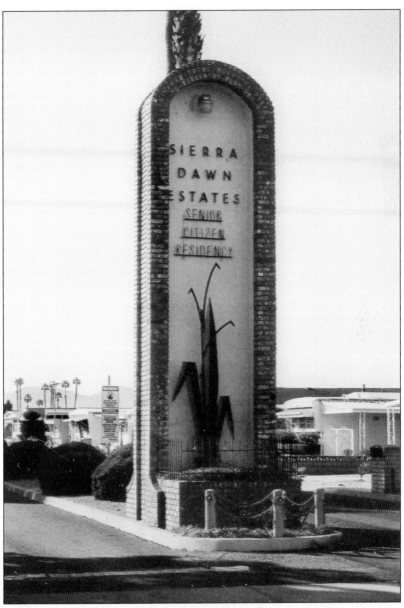

This fountain is located on the north side of Sierra Dawn Estates, a retirement community that provided Hemet with the distinction of being the first city in California where residents owned, rather than rented, their mobile home lots. Sierra Dawn Estates was the forerunner for Hemet to change from an agricultural-based area to a retirement-based community, with numerous mobile home and recreational vehicle parks established in and around the city after Sierra Dawn. Merlyn L. "Mack" McIntyre was the creator of Sierra Dawn when he converted 240 acres of his Sierra Dawn Farm in 1962 to a Sierra Dawn Estates subdivision. Mack submitted plans to the Hemet City Council for utilities to be placed under citywide streets. Lot owners could then participate in and pay for city utilities, such as streetlights, water, sewers, and garbage and trash pick-ups, and privately owned electricity, gas, telephone, and television services. To attract retirees, four recreation centers, all with swimming pools, were constructed and a social/activities director hired as Sierra Dawn Estates expanded.

This is a later picture of Merlyn McIntyre after he started the development of Sierra Dawn Estates in 1962. In order to realize his dream, Mack enlisted the financial help of other investors, one of whom was Art Linkletter of television fame. Linkletter not only helped financially but also personally, by advertising Sierra Dawn as in the "Foothills of Heaven," which proved very successful. (Courtesy Eleanor McIntyre.)

With snowcapped Mount San Jacinto in the background, Sierra Dawn Estates in the lower part of this picture is filling up with mobile homes close to the first recreation center, the large building in the center left. Some recreational facilities included shuffleboard, horseshoes, and bowling on the green. The land at the bottom of the picture is for more mobile homes and three more recreational clubhouses.

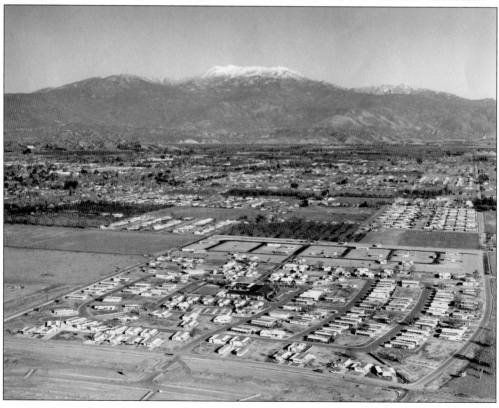

Merlyn McIntyre (left) is with Art Linkletter (center) and an unidentified man. Mack sold his Sierra Dawn interests to Linkletter Enterprises in 1963. Linkletter Enterprises sold its interests in 1968. In 1976, the Sierra Dawn Homeowners Association, Inc., purchased the Sierra Dawn recreational facilities, other buildings, and storage lots. In 2008, there were about 2,800 people living in 1,492 mobile homes in Sierra Dawn.

Sierra Dawn Estates not only started retirement living in Hemet, but it prompted a new industry, mobile home manufacturing plants such as Skyline Homes. In this picture, Bob Lawell drives his Bob's Trailer Towing truck, hauling a Skyline coach purchased for a lot in a park somewhere in Hemet.

As potential retirees discovered Hemet's great year-round climate and small-city atmosphere, many selected Hemet for their retirement years. The city encouraged them to come and started building amenities for them, which added to its attraction. The city built this very popular bowling on the green facility as part of Gibbel Park on the west side of town.

This picture tells a great story about retiring in Hemet with snowcapped Mount San Jacinto in the distance, a newly built housing subdivision, one of many on the valley floor, and retirees in shorts and shirtsleeves playing golf on a balmy day. This Landmark Golf Course was located on the west side of the city of Hemet.

Eight

HEMET TODAY

A wonderful story hides behind this picture. It began in January 1933 when the Metropolitan Water District of Southern California started building the Colorado River Aqueduct from Parker Dam 242 miles across low desert lands to Lake Mathews in Riverside County. From Lake Mathews, water was distributed to 13 Southern California communities in 1941. As the population of Southern California increased, water-storing reservoirs became a necessity to hold not only Colorado River water but also Northern California snowpack waters. In 1987, Metropolitan started planning for a huge reservoir site, finally selecting two connected valleys, Diamond and Domenigoni, four miles southwest of Hemet. In 1995, work began on this site with the construction of three dams, a fore bay, a power plant, and the nine-story Inlet/Outlet Tower in this picture. On March 18, 2000, over 4,000 people celebrated by watching the first water flow from the Inlet/Outlet Tower into Diamond Valley Lake, the largest freshwater lake in Southern California.

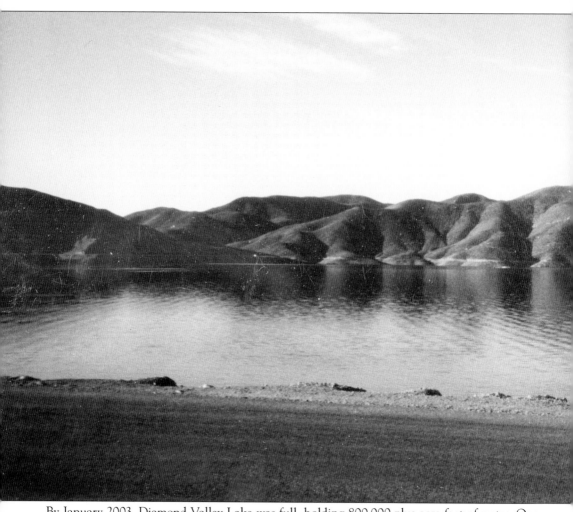

By January 2003, Diamond Valley Lake was full, holding 800,000-plus acre-feet of water. One acre-foot of water serves two families of four for one year. The deepest part of the lake is at the 1.8-mile-long, 280-foot-high Don Owen Dam on the west side. The East Dam is 2.2 miles long and 180 feet high. The Saddle Dam is the third dam, and it fills in the lowest part of the north hills, preventing water from flowing out when the lake is full. All three dams are earth-rock,

deemed better to withstand earthquakes. The distance around the lake is 21.1 miles, great for a marathon, hiking, and bicycling. The vastness of the lake invites sailing and kayaking but no swimming. During construction, enough dirt was moved to build a 3-foot-wide, 7-foot-high wall around the equator.

During the construction of Diamond Valley Lake, a group of Hemet and Metropolitan Water leaders started planning for two museums north of the lake to present prehistoric animal fossils, unearthed during construction, and the awareness of water. The outcome is this beautiful 10-tower structure. Metropolitan's Visitors Center occupies the first five towers. The remaining towers contain the Western Center for Archaeology/Paleontology.

This picture was taken inside the Visitors Center, where Metropolitan Water District presents the history of water and its significance in our daily lives. In addition, the Visitors Center attempts to stimulate and promote an awareness and appreciation of water-related issues—past, present, and future—and the importance of water to everyone living in California.

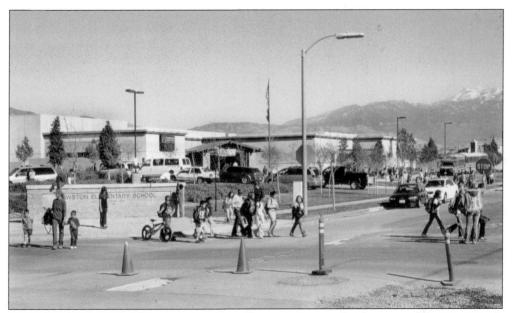

Like other Southern California communities, Hemet experienced a phenomenal housing growth during the first years of the 21st century, and new schools mirrored housing. This is a picture of Cawston Elementary School, opened in 2004 on Cawston Avenue on the west side of Hemet. The name of the avenue and the school came from Edwin Cawston, who operated an ostrich farm on this land from 1909 to 1914.

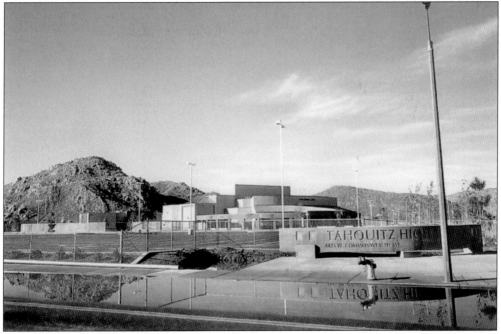

In 2007, Tahquitz High School opened, also on Cawston Avenue. This is Hemet's fourth high school, after oldsters Hemet and Alessandro High Schools and youthful West Valley High School. The name Tahquitz comes from the San Jacinto Mountains, wherein Tahquitz Peak, Canyon, Creek, Falls, Rock, and Valley exist. There is also the American Indian legend of Tahquitz.

In this state-of-the-art Hemet Unified School District Nutrition Center, breakfast and lunches are prepared and delivered daily to elementary, middle, and high schools and then served to students. For lunch, high school students could choose from eight different entrees per day and middle school students from five entrees, all prepared according to the district's wellness policy. Prices are nominal, but pizza wins hands down.

Next door to the nutrition center is the Hemet Unified School District Professional Development Service Center, which opened in 2008. This building is so huge and comprehensive that a person could get lost looking for everything from the superintendent's office to Student Support Services to Educational Services. In 2008, the Nutrition and Professional Development Service Centers served approximately 24,000 students within a 763-square-mile area.

After Diamond Valley Lake was constructed, Metropolitan Water District agreed to lease 80 acres to the Valley-Wide Recreation and Park District for a park. The first recreational facility constructed on the land was this swimming pool. The summer the pool opened, it was standing room only with youngsters anxiously waiting to use the pool and the huge waterslide it contained. (Courtesy Valley-Wide Recreation and Park District.)

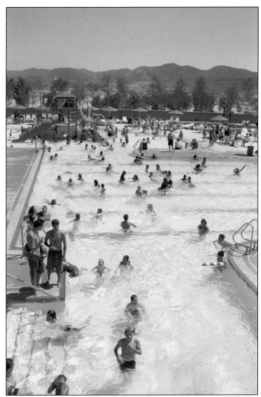

In July 1972, the residents of Hemet along with six other communities invested some of their property tax money in a Valley-Wide Recreation and Park District, covering 800 square miles. The new district hired Sam Goepp to lead the way, which he did with great success. After 23 years of dedicated and outstanding service, Sam retired in 2008. (Courtesy Valley-Wide Recreation and Park District.)

Tract after tract of homes became a fact of Hemet life during the first seven years of the 21st century. Three drawing cards for building these homes were lower housing prices, weather, and scenery, as evidenced by this magnificent view of Mount San Jacinto. These homes were built where apricots, peaches, walnuts, olives, and potatoes once grew.

In June 2003, this beautiful building opened with the words "Hemet Public Library" emblazoned on its front. This was Hemet's third library building, but unlike the first two, this building was planned large to accommodate growth. Until the time arrives when the library itself must occupy the entire building, community organizations and events, music programs, art and craft displays, all types of classes, and speakers use the Hemet Public Library.

This three-diamond, AAA-approved Hampton Inn, part of the Hilton family, was constructed in Hemet in 2005 and most welcomed. It provides 86 rooms and suites with free breakfasts. Guests may also use a heated pool and fireside Jacuzzi and fitness and business centers and have free massages. The inn is booked solid each year during the three weekends of the outdoor Ramona Pageant.

This San Jacinto Valley Veterans Memorial is located on a corner of Hemet's Gibbel Park. It honors the lost lives of 38 persons killed while serving in World War I, World War II, Korea, Vietnam, and Middle East wars. The names appear below a giant Purple Heart and the plaques of the Departments of the Army, Navy, Marine Corps, Coast Guard, and Air Force.

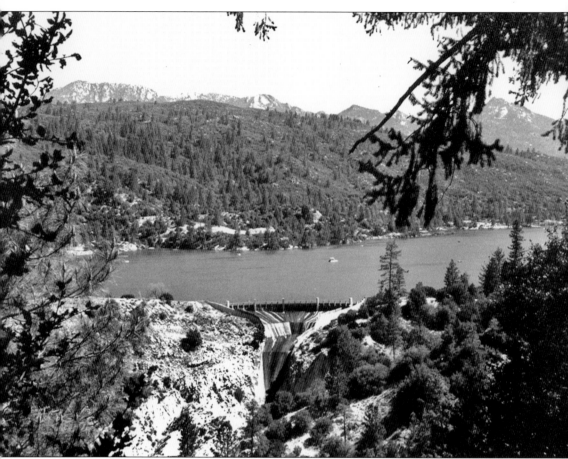

This book ends with a view of Lake Hemet from Willow Valley Trail in the San Jacinto Mountains. The structure in this picture is the spillway, reconstructed in 1982 and located a quarter mile southwest from the Lake Hemet Dam. When the lake is full, water goes over the spillway rather than the dam. In 1954, Hemet ranchers and growers decided that they wanted to own the dam, spillway, and the lake by forming a water district and purchasing all the Lake Hemet Water Company assets, owned by the descendants of William F. Whittier. In August 1955, the Lake Hemet Municipal Water District was formed, and district directors paid $525,000 to the Whittier heirs for all the assets of the Lake Hemet Water Company. In the 21st century, Lake Hemet water still travels down the San Jacinto riverbed to irrigate massive acreages of citrus groves. Lake Hemet is also a beloved mountain lake for fishing and for bald eagles to live in pine trees, catch fish, and soar over the San Jacinto Mountains.

BIBLIOGRAPHY

Andrews, Beryl Penacho. *Apricot Memories*. Hemet, CA: Self published, 2001.

City of Hemet. *Golden Anniversary Year 1910–1960*. Hemet, CA: City of Hemet, 1960.

Gunther, Jane Davies. *Riverside County, Place Names, Their Origins and Their Stories*. Riverside, CA: Rubidoux Printing Company, 1984.

Hemet–San Jacinto Genealogical Society. *San Jacinto Valley Past and Present*. Dallas, TX: Curtis Media Corporation, 1989.

Lake Hemet Water Company Papers, Hemet Public Library.

Robinson, John W., and Bruce D. Risher. *The San Jacintos*. Arcadia, CA: Big Santa Anita Historical Society, 1993.

Tapper, Violet, and Nellie Lolmough. *The Friendliest Valley*. Hemet, CA: Hungry Eye Books, 1982.

The Hemet News. *City of Hemet 75th Anniversary*. Hemet, CA: *The Hemet News*, 1985.

Whitney, Mary E. *Bring Me a Windmill*. Hemet, CA: Fortune Valley Books, 1985.

———. *Hemet and the Brudins*. Hemet, CA: Fortune Valley Books, 2007.

———. *Pieces of the Past*. Palm Springs, CA: Event Horizon Press, 2006.

———. *Valley, River and Mountain*. Hemet, CA: Hemet Area Museum Association, 1999.

———. *Vignettes of the Valley*. Hemet, CA: Hemet Area Museum Association, 2003.

———. *Whittier, Fuller & Company*. Hemet, CA: Hemet Area Museum Association, 2000.